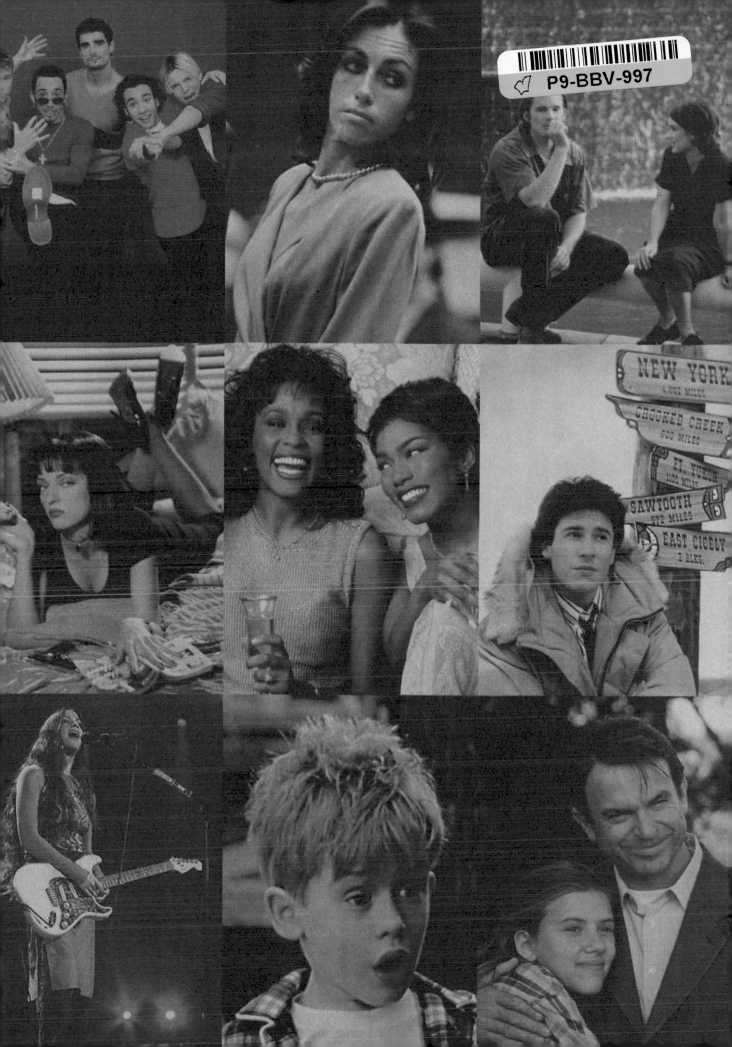

People

CELEBRATE

The'90s

TABLE OF CONTENTS

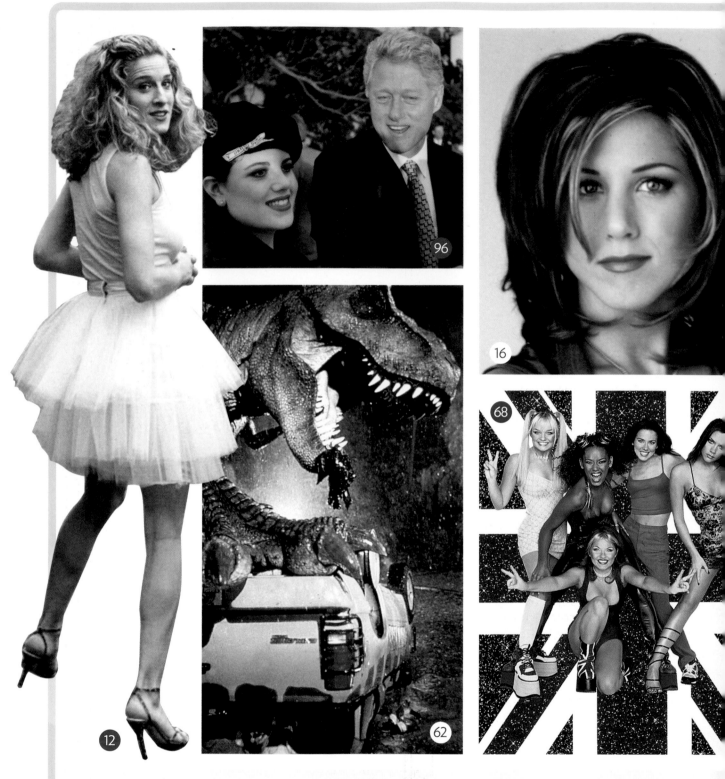

STAFF

Editor: Elizabeth Sporkin **Assistant Managing Editor:** Cynthia Sanz **Senior Editors:** Vick Boughton, Richard Burgheim, Tamara Glenny **Creative Director:** Rina Migliaccio **Art:** Phil Bratter (Design Director), Jason Arbuckle, Greg Monfries (Directors), Lisa Meipala Kennedy, Effendy Wijaya (Associate Directors), Ronnie Brandwein-Keats (Assistant Director), Dragos Lemnei (Designer), Rashida Morgan (Assistant Designer), Lisa Burnett (Production Artist) **Pictures:** Luciana Chang (Editor), Jessica Bryan (Associate Editor), Brian Belovitch (Assistant Editor), Kathryn Zarem (Picture Researcher), Urbano DelValle (Photo Desk) **Writers:** Joyce Chang, Lisa Helem, Mike Lipton, Elizabeth O'Brien Moore, Joanna Powell, Lisa Russell, Charlotte Triggs **Reporters:** Toby Kahn (Chief), Randy Vest (Deputy), Antoinette Coulton, Debra Lewis, Sabrina McFarland, Lesley Messer, Tina Redwood, Katie Tanner **Contributors:** Sarah Andrews, Michaele Ballard, Vickie Bane, Carrie Bell, Lorenzo Benet, Katie Block, Carrie Borzillo-Vrenna, Phil Boucher, Kevin Brass, Alexis Chiu, Champ Clark, Ivory Clinton, Tom Cunneff, Johnny Dodd, Ruth Andrew Ellenson, Jennifer Frey, Susan Christian Goulding, Sara Hammel, Isoul H. Harris, Steve Helling, Jessica Herndon, Julie Jordan, Shia Kapos, Amy Keith, Kate Klise, Marisa Laudadio, Ken Lee, Molly Lopez, Jennifer Odell, Alexandra Phanor, Robin Reid, Monica Rizzo, Jessica Skelly, Jenny Sundel, Jeff Truesdell, Cynthia Wang, Kelly Williams **Research:** Robert Britton (Director), Céline Wojtala (Deputy), Jane Bealer, Sal Covarrubias, Margery Frohlinger, Charles Nelson, Susan Radlauer, Annette Rusin, Jack Styczynski, Patrick Yang **Copy:** Tommy Dunne (Chief), Lance Kaplan **Imaging:** Robert Roszkowski **Administrative Assistant:** Patricia Hustoo

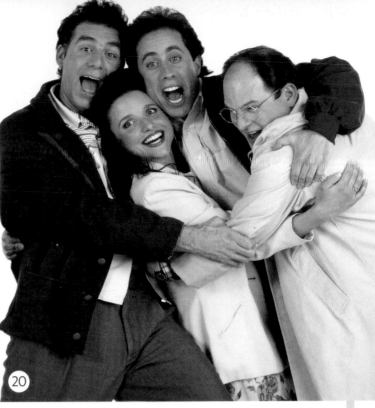

Time Inc. Home Entertainment Publisher: Richard Fraiman **Executive Director, Marketing Services:** Carol Pittard **Director, Retail & Special Sales:** Tom Mitsud **Marketing Director, Branded Businesses:** Swati Rao **Director, New Product Development:** Peter Harper **Financial Director:** Steven Sandonato **Assistant General Counsel:** Dasha Smith Dwin **Prepress Manager:** Emily Rabin **Marketing Manager:** Laura Adam **Book Production Manager:** Suzanne Janso **Associate Prepress Manager:** Anne-Michelle Gallero **Special thanks:** Bozena Bannett, Alexandra Bliss, Glenn Buonocore, Robert Marasco, Brooke McGuire, Jonathan Polsky, Chavaughn Raines, Ilene Schreider, Adriana Tierno, Britney Williams

RoSEaN

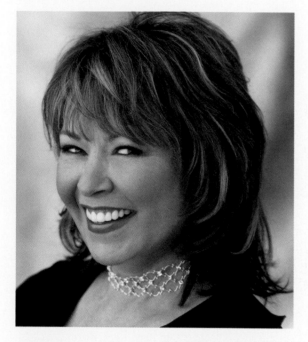

When people look back on the '90s, they're apt to remember the lighter side.

There were Beanie Babies, boy bands and Spice Girls. But I didn't know Posh from Scary or Justin from JC.

As far as I was concerned, the '90s was borrowed time. With Y2K coming at planet Earth like a comet on a collision course, I didn't think the human race was going to survive. I figured I had 10 years to do, say and be everything I ever wanted before it was too late, so that's what I did.

I laughed every chance I could.

I also cried, sang, dieted, dumped my second husband for a much younger third husband, had plastic surgery, raised my children, accused my parents of molestation, lived through a "tragic" singing accident, got artificially inseminated, gave birth, became a grandparent, reunited with a kid I had given up for adoption when I was still a kid myself, went insane and became a Republican. And while doing all that, I starred in a popular television series that made me rich and famous as well as queen of the tabloids. In other words, I did all the cool stuff.

I think Roseanne and Dan were an accurate reflection of the time. They were a very average couple consumed by their dream—buying a home and saving enough money to send their kids to college. That was a struggle then, and it's damn near impossible for working-class people now. I saw it coming and talked about it. It was serious stuff. But we laughed through the seriousness by telling the truth. For instance, take when Roseanne told Dan, "Your idea of romance is popping the can away from my face." And when she declared, "All human beings connect sex and love—except for men."

I'm proud of the issues we addressed on the series, including poverty, abuse, obesity, getting your first period, drugs and homosexuality. We stirred up controversy, but we also showed that every family can go through crap and still find love and laughter by the time the dishes are done and the laundry is folded. Ironically, when I decided that greed was bad and God was good and wrote both themes into the show, we were canceled.

By then I'd spent almost the entire decade working 15-hour days and had to catch up on the

E REMEMBERS THE '90s

The TV icon considers love, life, laughter and pop culture in the last decade of innocence

changes that had occurred while I was locked inside that soundstage. Getting a cup of coffee, for instance, required a wad of cash and several words of Italian. Grunge no longer referred to the dirty ring around the bathtub. One day somebody asked if I used Windows. "Hell, yeah," I said. "How else do you air out the bathroom?" And I had to become computer-literate so that when I was advised to "reboot" I didn't run out to Neiman Marcus.

As you can see in this book, the decade had something for everyone. If you didn't like *Roseanne* for being about "something," you could watch *Seinfeld,* a series about "nothing." In between you had *Melrose Place, Beavis & Butt-Head* and Barney singing about how he loved everyone. My escape was cable, where I could always find a show on Hitler or some serial killer.

While some pretty good movies were released, including *Goodfellas, Sleepless in Seattle, Titanic, Forrest Gump* and *Wayne's World,*

many will think of the '90s as the decade that launched the celebrity sex video,

as in Pamela Anderson and Tommy Lee. I would have released one too if I didn't hate sex so much, because after all that plastic surgery I looked hot.

As for music, my genius friend Frank Zappa died in '93, and one day in his declining months he told me that he was honored to have seen the birth and death of rock and roll, which is what the '90s were to him, and I'm not arguing with him. I was too busy writing my own books, so I don't know nothing

about the bestseller lists other than men like John Gray and Rush Limbaugh who thought they'd figured everything out. But they didn't address the stuff that people really obsessed about. Like whether Britney Spears had a boob job. Why Prince Charles didn't love Diana. And what was the easiest way to lose 20 lbs. without giving up sugar, salt, grease or starch. Personally, I loved that the President went for a fat girl.

For all the decade's silliness, there was a serious flip side:

the Soviet Union's breakup, the end of apartheid in South Africa, Princess Diana's death, the plane crash that killed John F. Kennedy Jr. and his wife. My friend Richard Pryor was silenced by MS, but in his place gangsta rap seeped into the mainstream and soon had people of all colors saying, "Whassup, homey?" Better still, I became phat, not fat.

I still obsess over certain things, namely Columbine, Oklahoma City and the mother lode of confusion and debate, the O.J. Simpson verdict. The '90s gave us a lot to talk about. If nothing else, it was an incubator for future tabloid queens. Thank goodness Hale-Bopp didn't destroy us, and Y2K, as far as I'm concerned, was a runaway anxiety attack that we've treated with gobs of Paxil, Valium and Ambien. Maybe that era was a last gasp of innocence before the jolt of 9/11. I'll leave the analysis for others. For me, those days were like a rat maze, and when I got through it I figured out the simple things worked best for me. Family is the only thing that matters. And you really do have to exercise and cut out the sugar.

The triple-threat team of Naomi Campbell, Christy Turlington and Linda Evangelista dove into the new decade with a splash at a Versace party in Paris in 1990.

'90ˢFA

Models evolved into supermodels, and stars set trends. High fashion had entered the mainstream

:LOOKS TO REMEMBER

It was a time of transformation, when less was more and style meant simplicity. In these shining red-carpet fashion moments, starlets became stars. A princess became the Queen of Hearts. And Sharon Stone surprised us all, again

● **GWYNETH PALTROW**
Ralph Lauren
In '99, she won the Oscar for Best Actress—and the dress became one of the bestselling knockoffs ever.

● **HALLE BERRY**
Valentino
She stunned in bias-cut lilac satin and draped velvet specially created for her at the Oscars in '96.

● **ELIZABETH HURLEY**
Versace
Her 24 safety pins at '94's London premiere of *Four Weddings and a Funeral* put her on the map.

● ...SS

Christina Stambolian
In '94 she wore what has become known as the "Up Yours" dress to her first public event after Prince Charles admitted cheating.

● NICOLE KIDMAN
Dior by John Galliano
The belle of the '97 Academy Awards, she stepped out of Tom Cruise's shadow and into the limelight in an embroidered, mink-trimmed sheath.

● SHARON STONE
Her husband's shirt and Vera Wang
Always a maverick, at the '98 Oscars she flaunted her newlywed status (to newspaperman Phil Bronstein) and started a trend.

● LIL' KIM
She had this jumpsuit and sticker made for the MTV Awards in '99. How did the pastie stay on? "We used an adhesive glue. I couldn't use Krazy Glue!"

● CELINE DION
Did she get dressed too fast? Nope—the Dior couture suit Dion wore to the '99 Oscars was designed to be worn backward.

● ROSE McGOWAN
Trying to rival her then-boyfriend Marilyn Manson, she said, "There's not a lot of options besides nudity." A thong and some sparkly strings at the '98 MTV Awards filled the bill.

:LOOKS TO FORGET
Hooray for Hollywood—and the exuberance of its excess! Taking fashion risks to make a splash is what it's all about—even if the results are sometimes all wet. Before there were stylists, even the beautiful people could go very wrong

GEENA DAVIS
Costume designer Bill Hargate designed it for her trip to the Oscars in '92. Ever the diplomat, Donna Karan called it "the dress of the night."

WHOOPI GOLDBERG
Bill Hargate does it again! "After all, it is Hollywood," Goldberg said of the pants/ballgown combo she wore to the Academy Awards in '93.

:MEMORABLE FASHION MOMENTS

Take a trip back and check out the looks that defined a decade—and the stars who turned them into trends: The good, the bad and the just plain what-were-they-thinking . . .

THE WONDERBRA
In 1994, it pushed up, divided and ruled. Sped by armored car to waiting hordes of women, the bras flew out of stores, which couldn't keep them in stock. Kate Moss was a convert: "I swear, even I can get cleavage from them!"

GRUNGE
NIRVANA
Seattle's clouds and damp gave birth to a moody new sound and a style—layers of flannel over grubby tees, matted hair falling into disillusioned eyes—that appealed to slacker teens and a fashion world bored with '80s excess.

BRIEFS, NOT BOXERS
What began as a part of Marky Mark's rap act—a trou-dropping finale—became a craze: tighty-whities on parade.

Hammer Pants
MC HAMMER
Bursting onto an unsuspecting world in the "U Can't Touch This" and "Too Legit to Quit" videos, the signature genie pants—a perfect fusion of fashion and function, according to Hammer—became a go-to '90s look. "I asked some designers to create a pair of pants that would allow me to move freely and accentuate my body movements," he said. He even poked fun at himself in a Taco Bell ad, jumping off the top of a building and letting his enormous pants gently parachute him to earth. In 1994, though, he abandoned the look for a Speedo-style swimsuit in his "Pumps and a Bump" video—and a career low point. The lesson? Fans preferred the pants.

BLING
● **SNOOP DOGG**

To be a true mack daddy like Snoop or Diddy, you had to drip with diamonds or be rolling in "bling," a term Tupac popularized in his rap "F--- Friendz."

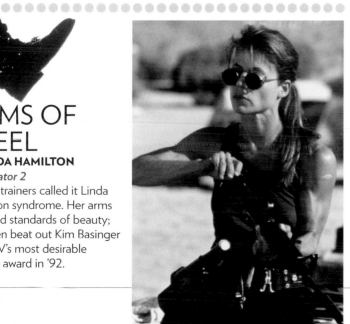

Sex and the City
SARAH JESSICA PARKER
Where would Manolos and Fendi bags be without Carrie? And how did a newspaper girl with one weekly column pay for it all?

ARMS OF STEEL
● **LINDA HAMILTON**
Terminator 2
Fitness trainers called it Linda Hamilton syndrome. Her arms changed standards of beauty; she even beat out Kim Basinger for MTV's most desirable woman award in '92.

Red Carpet Midriff
● **JENNIFER ANISTON**
The bared midriff went legit when Hollywood A-listers—like Gwyneth Paltrow and Halle Berry, as well as the breakout star of TV's biggest sitcom—started sporting well-toned abs as their hottest accessory.

:SUPERMODELS

Linda, Cindy, Naomi and Christy—it was the era when last names were superfluous

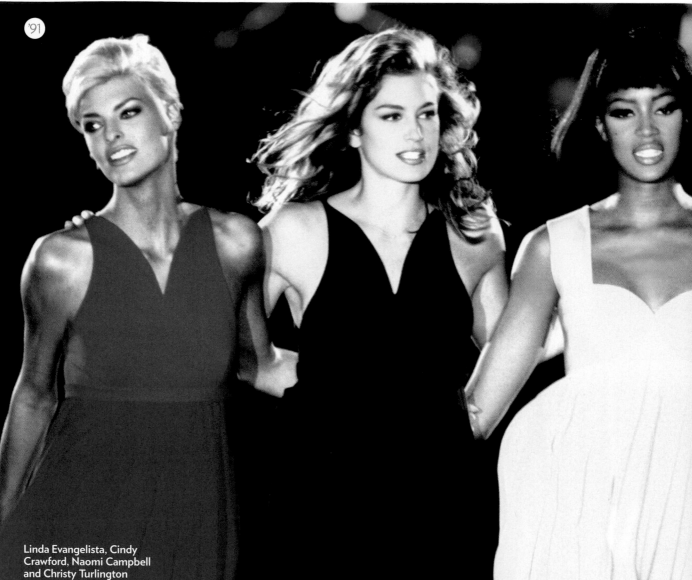

'91

Linda Evangelista, Cindy Crawford, Naomi Campbell and Christy Turlington dominated the runway.

Linda Evangelista

● Quoted as saying she wouldn't get out of bed for less than $10,000 a day, Evangelista sparked an anti-supermodel backlash. At 41, having successfully battled weight gain, she still models, promoting M.A.C's Viva Glam Lipstick, with sales benefiting the company's AIDS fund.

Cindy Crawford

● Her film career may have had flaws (*Fair Game*, anyone?), but with her fresh, healthy look—and that beauty mark—the 5'9" stunner was the ultimate cover girl. The original host of MTV's *House of Style*, Crawford, 40, has settled down with husband Rande Gerber and kids Presley, 7, and Kaia, 4.

Naomi Campbell

● She's ruled the runway for more than 15 years, starring in Ralph Lauren and Versace campaigns, but Campbell, 36, is also known as the queen of tantrums, the latest leading to an assault charge in March 2006 after she allegedly threw her crystal-encrusted BlackBerry at her housekeeper's head.

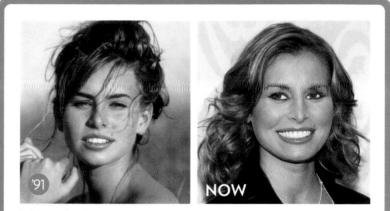

'91 NOW

Niki Taylor

● Discovered at 14, Taylor became the face of Cover Girl at 17 (then the youngest ever) and a fixture on magazine pages. But the smooth career hit roadblocks: In 1995 she found her model sister Krissy, 17, dead of an asthma attack at home; in 2001 her liver was severely damaged in a near-fatal car crash. Now 31, the single mom lives in Florida with her 11-year-old twin sons Jake and Hunter.

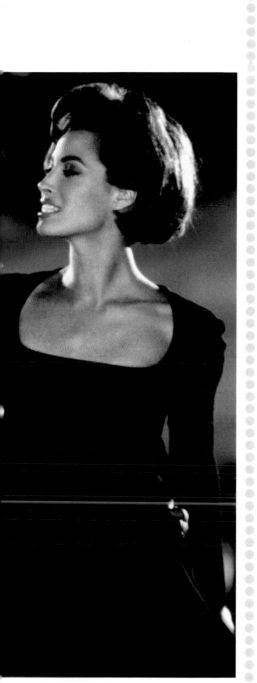

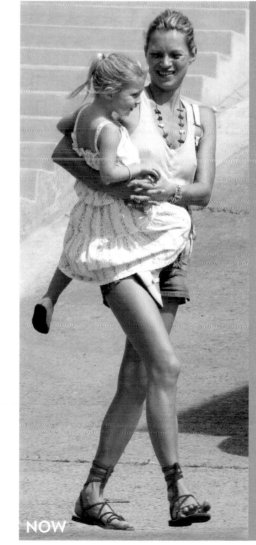

NOW

KATE MOSS

● Her sultry Calvin Klein perfume ads made Kate Moss a household name at 19. They also stirred controversy among those who blamed the stick-thin model for glamorizing the waif look. Caught on-camera snorting cocaine in '05, the 32-year-old mother of Lila, 3, went off to rehab and has since made a warp-speed comeback.

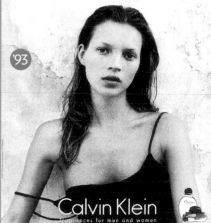

'93

Calvin Klein
fragrances for men and women

Christy Turlington

● One-third of the original super-model triumvirate (with Linda and Naomi), the Calvin Klein muse recently designed Nuala, a yoga-wear collection, for Puma. Now 37, she and her husband, actor-director Edward Burns, live in New York City with their daughter Grace, 3, and son Finn, 5 months.

HAIR DOS (& DON'TS) OF THE DECADE

Women demanded "Rachel" cuts, guys went for frosted tips, and way too many folks of both genders proudly sported mullets. Some styles were hits, others just plain hairy

● **THE RACHEL**

Jennifer Aniston
The layered, high-lighted bob Jennifer Aniston wore on *Friends* was, simply, the most requested do of the '90s. Stylist Chris McMillan told In Style he just "chopped off" her locks to create it. The secret? Drying the hair soaking wet, not toweling first. The basic cut is still huge, says celeb stylist Frédéric Fekkai, because the graduated layers flatter so many face shapes.

THE STYLE OF THE DECADE!

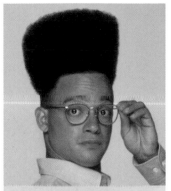

● **THE HERSHBERGER**
Meg Ryan
Ryan made stylist Sally's cute, fresh shag a look that's still cutting edge.

● **HIGH-TOP FADE**
Kid
This height-enhancing hairdo was a *House Party* hit.

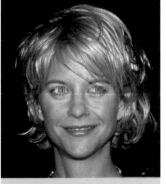

● CAESAR
George Clooney
Et tu, George? On Clooney, the classic short cut looked pretty darn good.

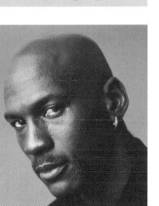

● **BALD**
Michael Jordan
An instant fashion slam dunk, Jordan's ultimate sleek look was widely copied.

● **BUZZ POMPADOUR**
Vanilla Ice
A blond wisp with shaved designs—was the look all that nice, nice, baby?

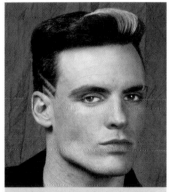

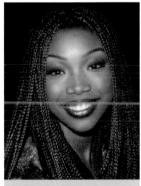

● **BOX BRAIDS**
Brandy
She added a twist to Afrocentric beauty with her Senegalese-style two-toned plaits.

● **MULLET**
Billy Ray Cyrus
Business in the front and party in the back—country boys were of two minds.

● FROSTED TIPS
Lance Bass
The bleaching gave baby-faced boy-banders the illusion of a hipper edge.

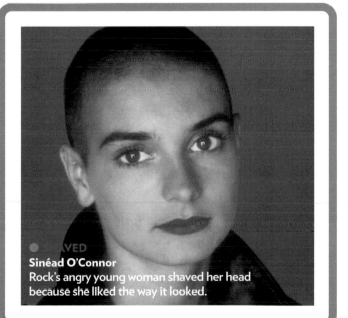

● SHAVED
Sinéad O'Connor
Rock's angry young woman shaved her head because she liked the way it looked.

:THOSE FANTASTIC FADS

If you didn't tickle Elmo, stretch your eyeballs on a Magic Eye or your hamstrings on a ThighMaster, can you say you fully experienced the '90s? Fear not. Most of these items are still to be found on eBay

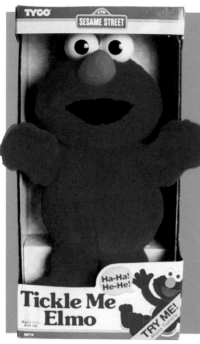

TICKLE ME ELMO

In the holiday season of 1996, Tyco's vibrating, giggling *Sesame Street* spinoff was the must-have toy, and Elmo-mania swept the country. Short supply and high demand (fueled in part by talk show host Rosie O'Donnell, who raved about them) led to scenes of stampeding shoppers and parents literally fighting in store aisles. Scalpers took out ads, selling the $28.99 doll for as much as $1,500—and giggled all the way to the bank.

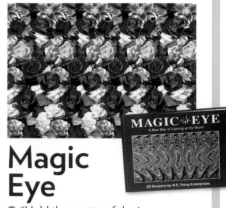

Magic Eye

"Hold the center of the image up to your nose. It should be blurry. Slowly move the image away from your face . . ." So ran instructions for Magic Eye, the "aerobics for the eyes" craze that let you trick your eyes into seeing 3-D images. In the mid-'90s it went by in a blur that included a comic strip and three bestselling books.

Snapple

Seinfeld had a fridge full of it. Howard Stern touted it on the radio. Those Snapple Lady (Wendy Kaufman) commercials generated 3,000 letters a week. The kosher iced-tea-making company had been around since 1972 but finally came of age in '93 as sales hit over $500 million. How many "Real Facts" caps did you collect?

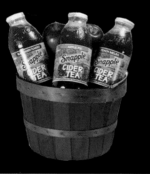

THIGHMASTER

Who admitted to owning one? Yet somehow more than 10 million units have been sold since '88. "It's like Kleenex," said tireless pitchwoman Suzanne Somers, who claimed to use hers twice a day (she still endorses it). "It's cheap and it works."

Beanie Babies

You remember: Those cuddly little sacks of pellets were going to pay for college someday. At the height of Beanie-mania, rare models like Peanut the Elephant in royal blue sold on the Internet for $4,500, 900 times their $5 sticker price. But critter collecting proved risky. The Beanie bubble burst in late 1999, and today even Peanut sells for peanuts on eBay.

BABY-G WATCH

● There came a moment in 1997 when a young girl's lust turned from boy bands to something even cuter: the Baby-G. Part toy, part timepiece, Casio's colorful computerized watches—a smaller, feminine version of the durable G-Shock sports models—came in translucent pastels with light-up faces and little men who could breakdance or surf at the push of a button. Baby-G gave Swatch major competition and became a collector's item—batteries included.

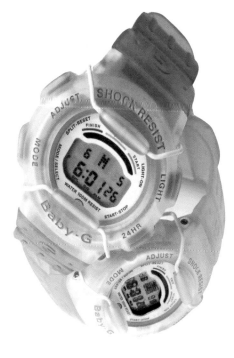

Pokémon

● A shortage of trading cards whipped up a Pokémon tsunami at Christmas 1999; by Y2K, merchandise featuring Pikachu and pals (who got their start as characters in a Japanese video game) had generated $6 *billion*.

Where's Waldo?

● For a skinny guy with nerdy glasses, Waldo sure got around. In five bestselling picture books by English writer and illustrator Martin Handford, our hero was hidden somewhere in every densely packed scene. But it took a Waldo whiz to spot him each time.

Scrunchies, Fanny Packs & Rollerblades

● Seems as if fabric-covered ponytail holders get no respect anymore. Same with those handy hands-free bags at your waist. But back when the world was learning to blade, they meant certainty: There was always an instant do and a place to stash the keys.

SCRUNCHIES

FANNY PACKS

ROLLERBLADES

TV'S No. 1 SHOW

In 2002, *TV Guide* named *Seinfeld* the best series of all time, topping even *I Love Lucy*.

MUST-SEE tv

From *Seinfeld,* the show about nothing, to *Twin Peaks,* the show about nothing anyone understood, '90s TV was one giant step outside the traditional television rule book. Quirky characters reigned and innovative plot twists kept the watercooler crowd buzzing

SEINFELD 1989-1998

Take away the Pez dispenser and the poisoned envelopes, burning issues like shrinkage, regifting and mastering one's domain, assorted nuts like the Soup Nazi and the Bubble Boy, yada yada, and whaddaya got? A show about nothing more than four single neurotic New Yorkers who, for nine glorious seasons, skewered the dating scene, trashed the workplace, punctured political correctness and carved out a hip, bizarro sitcom for the ages

THEN
From left: Louis-Dreyfus, Alexander, Seinfeld and Richards.

WHERE ARE THEY NOW?

● JULIA LOUIS-DREYFUS
Elaine Benes
In her two sitcoms since *Seinfeld*, she has played a lounge singer and a single mom. In real life, Louis-Dreyfus, 45, married with two sons, has described herself as "a card-carrying environmentalist." But at heart she's still hyperkinetic Elaine. She quit yoga, she said, because "I kept thinking, 'Let's pick up the pace.'"

● JASON ALEXANDER
George Costanza
After two failed sitcoms, he starred in the L.A. production of *The Producers*. Unlike manic George, "the real me is pretty shy, sober and serious about stuff," Alexander, 47, the married father of two sons, told the AP. Which explains his activism in One Voice, a Middle East peace group. Serenity now, anyone?

● JERRY SEINFELD
Jerry Seinfeld
Like his TV persona, he was a commitment-phobic bachelor—until he wed publicist Jessica Sklar in 1999. He was 45, she was 28. Now dad to three, Seinfeld admits fatherhood has changed him. Though he still does stand-up shows, "the best laughter in the world is little kids'," he told *Today*'s Katie Couric.

● MICHAEL RICHARDS
Cosmo Kramer
The so-called *Seinfeld* curse may have struck Richards, 56, hardest. His private-eye sitcom fizzled in 2000. Since then, his credits have been sparse. Though Richards, divorced with one daughter, and Seinfeld have socialized, "I miss the friendship and the family," he told Oprah about his old TV gang.

Jerry's Women

Think you know the man had commitment issues! Bit parts on the show about nothing led to plenty of something for these future leading ladies

WENDIE MALICK She was a physical therapist who insisted Jerry kiss her whenever they met.

AMANDA PEET As energetic Lanette, she was too much girl-friend for Jerry to keep up with.

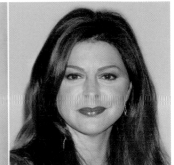

JANE LEEVES Playing a virgin led to roles in *Frasier* and Broadway's *Cabaret*.

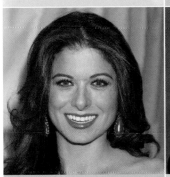

DEBRA MESSING Pre-*Will & Grace*, she played half of a newly separated married couple.

KRISTIN DAVIS After her toothbrush fell in the toilet, Jerry flushed their fling.

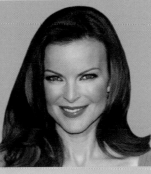

MARCIA CROSS She was a daft dermatologist Jerry dubbed Pimple Popper, M.D.

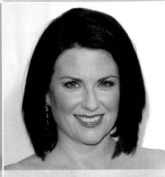

MEGAN MULLALLY George tried to woo his new girl by escorting her to her aunt's wake in Detroit.

MARISKA HARGITAY She auditioned as "Elaine" in Jerry and George's TV pilot for NBC.

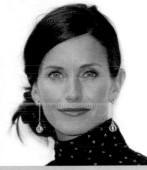

COURTENEY COX The future Friend and Jerry feigned marriage for cheap dry cleaning.

TERI HATCHER Her character's parting shot to Jerry: "They're real—and they're spectacular!"

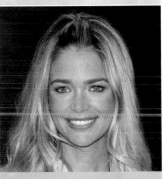

DENISE RICHARDS She shone as a network executive's daughter with distracting cleavage.

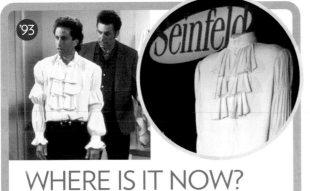

WHERE IS IT NOW?

Jerry's puffy shirt resides on the third floor of the National Museum of American History.

The Seinfeld Touch

What Seinfeld curse? These players came out on top

● **JOHN O'HURLEY** After *Dancing with the Stars*, the actor who played J. Peterman will host *Family Feud*.

● **LARRY DAVID** The sitcom's co-creator is $200 million richer and the star of *Curb Your Enthusiasm*.

● **THE SOUP NAZI** Al Yeganeh (right) has used his notoriety to launch a chain of gourmet-soup franchises. (*No soup for Jerry!*)

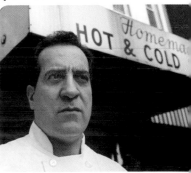

NORTHERN EXPOSURE
1990-1995

This offbeat series about a New York City doctor sent to small-town Alaska instantly struck a chord among viewers in the Lower 48. PEOPLE reunites the cast that blazed a Yukon trail of audacious romances, oddball plotlines and wry humanity

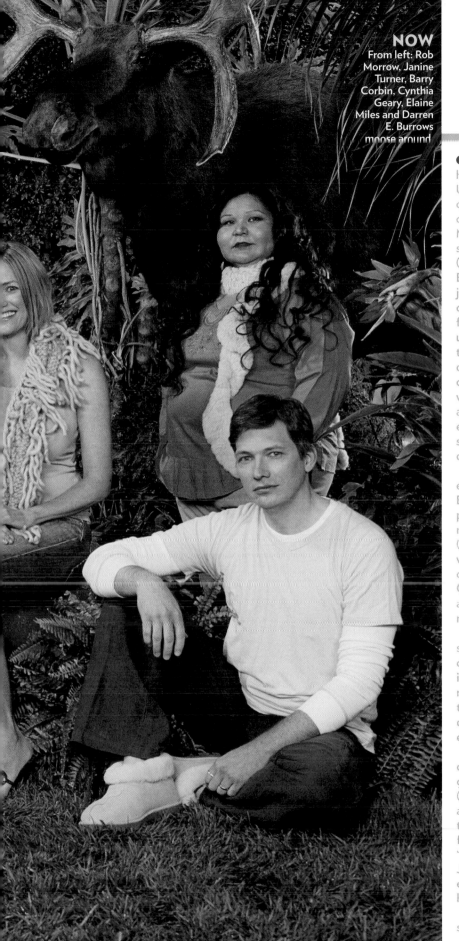

● Was there ever a more unlikely hit series than *Northern Exposure*? Unfolding in the obscure town of Cicely, Alaska, it boasted eccentric characters with names like Maurice Minnifield and Marilyn Whirlwind, specialized in weird occurrences (like the space satellite that fell to Earth, killing one of Maggie's many jinxed boyfriends) and reveled in the odd couplings of, among others, freewheeling bush pilot Maggie and uptight doctor Joel and graying tavern owner Holling and his 18-year-old girlfriend Shelly. Audiences and critics, disarmed by the show's winsome humor, ate it all up. During a five-year run on CBS, *Exposure* earned Top 20 ratings, achieved cult status and even picked up a best drama Emmy in 1992.

"It was a show about a place that everybody wished existed," says Barry Corbin (Maurice). And it was populated by characters "we all recognized," says John Cullum (Holling), "fathers, uncles and cousins who didn't quite fit in, who were at odds a lot, but when they got to Cicely they made it work. It gave you a sense of community that was rough-and-tumble."

The same could be said of the show's eclectic, mostly unknown cast. "Our first season, we all stayed in these efficiency apartments," recalls John Corbett (Chris). "It was the first time in my life I had all this dough. I spent three grand on beer every month."

At the beginning, "everybody couldn't be more different in our group," says Darren E. Burrows (Ed Chigliak). Yet "by the time the attention came on us [midway through the first season], we had found a real funky groove," he says. "Everything I've done since," says Janine Turner (Maggie), "I've never experienced the bond that we all had as a cast."

To Rob Morrow (Joel), shooting the show in the Seattle area was an extra

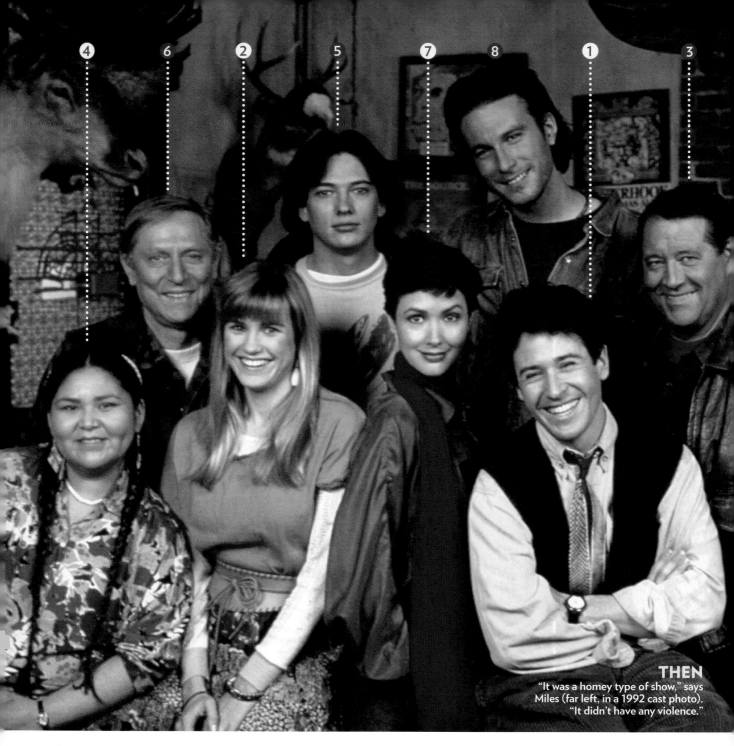

THEN
"It was a homey type of show," says Miles (far left, in a 1992 cast photo). "It didn't have any violence."

bonus. "At the time, there was this whole music scene that was really happening," he says. "I used to run into Kurt [Cobain] and Courtney [Love]. We were always flying back and forth to L.A. together. They were sweet."

Cynthia Geary (Shelly) loved Seattle so much, she still lives in the area. "It afforded me a certain lifestyle, which is great," says Geary, who has a lakeside home with her husband and two kids and only acts occasionally. "We have our ski boat in the backyard, and we're 45 minutes from snow skiing."

But in 1995, after five years together, it was time for the rest of the cast to

leave town. *Exposure,* says Corbin, "was a lot of fun to do until the last season. The scripts weren't as good." And Rob Morrow's decision to bolt midseason to make movies disappointed the show's fans and sealed its fate. Morrow remains grateful. "It was like going to film school for five years," he says. "I got the dailies every day and immersed myself" in the production process. He even argued with the producers about his character's send-off. "Josh [Brand, *Exposure*'s cocreator] always felt that Joel would go back to New York and would step into the life he always wanted [as a big-city physician]," says

Morrow. "I didn't care for that ending. He's on a boat in New York Harbor in the last shot, but I think of it as mythical rather than literal. I'd like to think Joel moved on and didn't go back to the life you'd expect."

His final episode (in which Maggie has rejected Joel's plea to come live with him) was emotional on-camera and off. "I was crying when we were shooting it," says Morrow, "and so was Janine." Turner, for one, hopes someday to return to Cicely for a TV-movie sequel. "I think people would love to see [the show again]," she says. "There's never been anything else like it."

WHERE ARE THEY NOW ?

1 ROB MORROW
Dr. Joel Fleischman
Morrow, 43, left the show midway through its final season to costar in the '94 movie *Quiz Show* and take on other big-screen roles. In 1998 he married actress Debbon Ayer, who delivered their only child, daughter Tu (as in "tomorrow"), three years later. Now playing an FBI investigator on the CBS crime show *Numb3rs,* Morrow recently directed an episode. But don't page Dr. Fleischman for an *Exposure* reunion movie. "I don't want to repeat myself," he says.

2 CYNTHIA GEARY
Shelly Tambo
"I'm enjoying motherhood," says Geary, 41, who gave birth in January to Lyla, her second daughter with husband Robert Coron, a commercial real-estate developer.

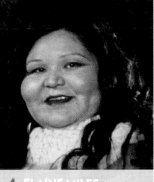

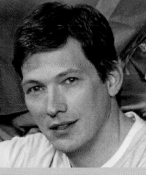

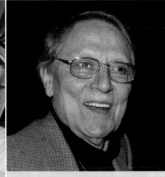

3 BARRY CORBIN
Maurice Minnifield
The twice-divorced Corbin, 65 and single with four grown children, now costars on The WB's *One Tree Hill* and relaxes on his 15-acre Fort Worth ranch.

4 ELAINE MILES
Marilyn Whirlwind
With acting gigs sporadic, "I started doing stand-up comedy about five years ago," says Miles, 46, a single mom to son Dustin, 12. "I do a lot of the Indian casinos."

5 DARREN E. BURROWS
Ed Chigliak
The actor, 39, who's half Native American, shares a ranchette outside L.A. with wife Melinda Delgado, a French chef, and their four sons, ages 3 to 11.

6 JOHN CULLUM
Holling Vincoeur
At 76, "I'm still kicking," says the stage veteran (*Show Boat, Urinetown*). Married to playwright and dancer Emily Frankel, he now performs mostly Off-Broadway.

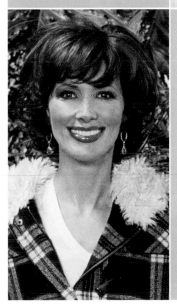

7 JANINE TURNER
Maggie O'Connell
"People still call me Maggie," says Turner, 43, who has continued in television (Lifetime's *Strong Medicine*). In 1997, the same year she played June Cleaver in the *Leave It to Beaver* movie, she gave birth to daughter Juliette, now 8, with whom she shares a ranch near Dallas. "She's my everything," says Turner. "I loved her father [whom the actress won't name]. Since then, I've had blind dates. Everybody wants to set me up."

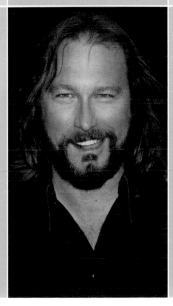

8 JOHN CORBETT
Chris Stevens
Bored with playing nice guys—he was the groom in 2002's *My Big Fat Greek Wedding* and Sarah Jessica Parker's boyfriend Aidan on *Sex and the City*—Corbett, 45, quit acting a few years ago to fulfill his dream to be a country music star. The cover photo of his self-titled first album was taken by girlfriend Bo Derek, who also appears in the video of his single "Good to Go." "We're going great," he says. "We've been together for four years."

BEVERLY HILLS, 90210 1990-2000

Never had TV teenagers been so rich or so well-coiffed. These eight pals ruled sunny West Beverly High, but life wasn't perfect. Andrea loved Brandon. Brandon loved Kelly. Kelly sometimes loved Brandon, sometimes Dylan. And David would have to wait until graduation for his big night with the virtuous Donna. But for all the angst and drama, nothing was so bad it couldn't be fixed over pie at the Peach Pit

WHERE ARE THEY NOW?

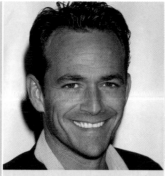

1 LUKE PERRY
Dylan McKay
With a new series, *Windfall*, on his résumé, Perry, 39, admits he's happy to be past his teen-idol years. "There's nothing I miss about that," he says. "Not the screaming, not the yelling."

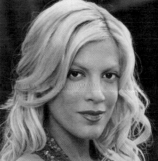

2 TORI SPELLING
Donna Martin
Now with actor Dean McDermott—she split from Charlie Shanian in '05—Spelling, 33, pokes fun at her life on the sitcom *So NoTORIous*. "Nothing's off-limits," she says. "Why hold back?"

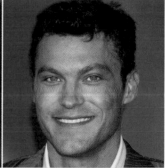

3 BRIAN AUSTIN GREEN
David Silver
Green, 32, returned to TV in '05 on *Freddie*. His other big role: single dad to Kassius, 4. "My son got me [a ring] for Father's Day. I'm married to him."

4 JENNIE GARTH
Kelly Taylor
Garth, 34, has traded Beverly Hills glamour for family life. "I feel most beautiful being with my husband and two kids," says Garth, who is married to actor Peter Facinelli.

5 IAN ZIERING
Steve Sanders
Though he now focuses on his work as a director, Ziering, 42, doesn't mind riding the *90210* fan wave. "All the time, people are like, 'Oh my God, Ian Ziering!'" he says. "It's very flattering."

6 GABRIELLE CARTERIS
Andrea Zuckerman
"We were a family—good, bad, whatever," Carteris, 45, says of the *90210* gang. The mother of two resurfaced in *The Surreal Life* in '02 and played a parent in cable's *Palmetto Pointe*.

7 JASON PRIESTLEY
Brandon Walsh
After surviving a fractured spine in an '02 car crash, Priestley, 36, reconnected with his *90210* pals. "Luke came right away," says the actor, who's married to make-up artist Naomi Lowde.

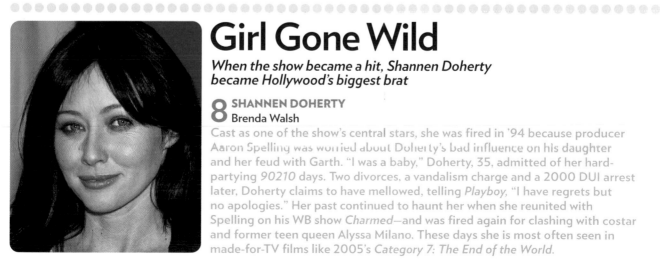

Girl Gone Wild
When the show became a hit, Shannen Doherty became Hollywood's biggest brat

8 SHANNEN DOHERTY
Brenda Walsh
Cast as one of the show's central stars, she was fired in '94 because producer Aaron Spelling was worried about Doherty's bad influence on his daughter and her feud with Garth. "I was a baby," Doherty, 35, admitted of her hard-partying *90210* days. Two divorces, a vandalism charge and a 2000 DUI arrest later, Doherty claims to have mellowed, telling *Playboy*, "I have regrets but no apologies." Her past continued to haunt her when she reunited with Spelling on his WB show *Charmed*—and was fired again for clashing with costar and former teen queen Alyssa Milano. These days she is most often seen in made-for-TV films like 2005's *Category 7: The End of the World*.

∶ALLY McBEAL 1997-2002

The hit dramedy about a lawyer and her love life won its place in TV history by focusing on what was inside Ally's head—those visions of bigger breasts, dancing babies and arrows plunging through the heart that brought her fantasies to life. And there were offscreen arrows too: Critics complained that the post-feminist heroine was too marriage-minded and wished that Calista Flockhart would eat a sandwich

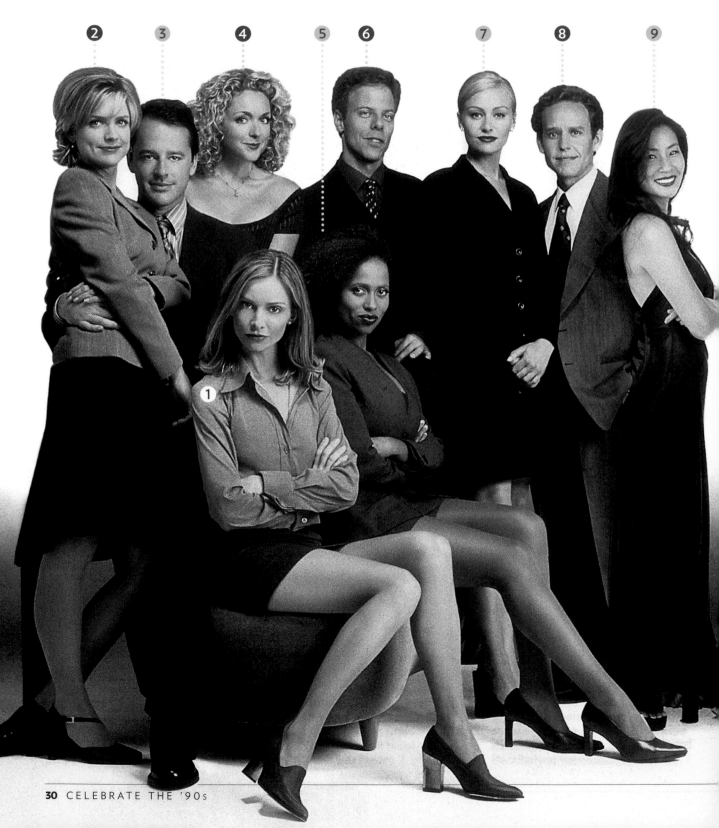

WHERE ARE THEY NOW?

1 CALISTA FLOCKHART
Ally McBeal
Partnered with Harrison Ford since '02, Flockhart, 41, has spent recent years bringing up son Liam, 5. She plans an '06 return to TV in the drama *Brothers and Sisters*.

2 COURTNEY THORNE-SMITH
Georgia Thomas
Resurfacing on the less trendy sitcom *According to Jim*, the actress, now 38, says, "I've been on cool and edgy. I care about being happy."

3 GIL BELLOWS
Billy Alan Thomas
Besides appearing in films like '05's *The Weather Man*, the actor, 37, has spent his post-*Ally* years raising children Ava and Giovanni with actress wife Rya Kihlstedt.

4 JANE KRAKOWSKI
Elaine Vassal
Returning to her Broadway roots, Krakowski, 37, won a Tony award in 2003 for her performance as Antonio Banderas's sultry mistress in the musical *Nine*.

5 LISA NICOLE CARSON
Renee Raddick
Arrested in 2000 for screaming obscenities in public, Carson, 36, left *Ally* in '01 after being hospitalized. She has since disappeared from showbiz.

6 GREG GERMANN
Richard Fish
After *Ally*, Germann, 48, continued to appear in TV and film projects. His latest: *Friends with Money*, with Jennifer Aniston.

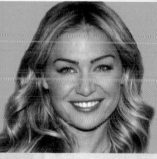

7 PORTIA DE ROSSI
Nell Porter
De Rossi, 34, costarred in the cult TV fave *Arrested Development*, battled anorexia and in '04 began dating Ellen DeGeneres.

8 PETER MacNICOL
John Cage
Wed since 1986 to Marsue Cummings, MacNicol, now 48, has a recurring role as an astrophysicist on the CBS drama *Numb3rs*.

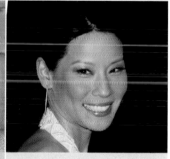

9 LUCY LIU
Ling Woo
Charlie's Angels made her a movie star, but Liu, 37, keeps up with her *Ally* pals: "Jane, Gil and Peter and I all get together for dinner."

Five Reasons *Ally* Kept Fans Talking

- **That unisex bathroom** Ground zero for gossip, trysts and embarrassing situations.
- **Miniskirted suits** Worn with bare legs—in winter! In Boston! They started a fashion trend.
- **The soundtrack** Headlined by Vonda Shepard singing the show's theme "Searchin' My Soul," the album hit No. 10.
- **The dancing baby** (right) The animated tyke boogied to the tick-tock of Ally's biological clock and became a popular screen saver.
- **The incredible shrinking cast** Acting beside the stick-thin Flockhart put pressure on female costars, who grew thinner by the week. Thorne-Smith later said she was "undereating and over-exercising" and obsessed with "thinking about food and being upset about my body."

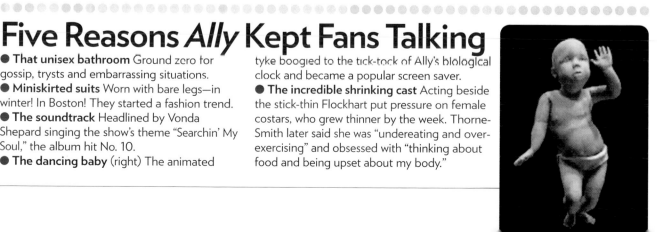

:BOY MEETS WORLD 1993-2000

Six years after the last episode, PEOPLE reunites the cast of *Boy Meets World*— the underappreciated teen sitcom that found its biggest following in reruns

A critic's darling? Hardly. A Top 10 hit? Not once. *Boy Meets World* never even cracked the Top 30 in the Nielsen ratings. Yet the coming-of-age series lasted long enough on ABC's Friday night "TGIF" lineup for 11-year-old Cory Matthews (Ben Savage) to finish high school, go to college and marry his crush Topanga (Danielle Fishel). "We were the little engine that could," says Will Friedle, who played Cory's brother Eric. "We just kept going and going."

Flying below the radar suited the teen stars just fine. "We got the benefits without too much of the negatives," says Savage. "All of us benefited financially because of the show. We were just kind of good, stable kids. There were no people camped in our front yards."

"We had a very loyal fan base," adds Friedle, "but at the height of our popularity I would meet lots of people who had no idea who we were."

They do now. "I don't think *Boy Meets World* ended when it ended," says Rider Strong, who as Cory's tough friend Shawn was the show's breakout teen idol. "We were popular after we were canceled because the Disney Channel was running it all the time. Now college students and retail people recognize me wherever I go. It's become a lot harder at the rental-car counter."

The four are still friendly—and still normal. "None of us has been to rehab," says Fishel. "None of us is robbing convenience stores."

"Our *E! True Hollywood Story* would be the most boring hour of television since the opening of Al Capone's vault," adds Friedle. "The E! voice-over guy would be like, 'And they all got along.' "

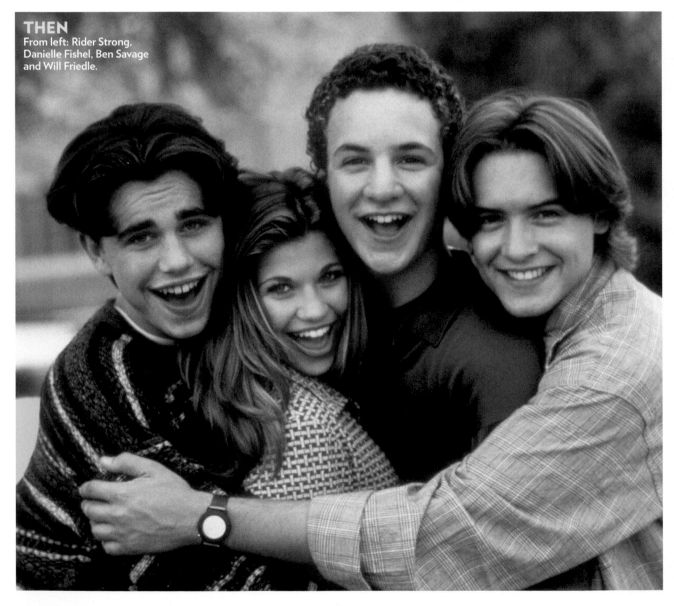

THEN
From left: Rider Strong, Danielle Fishel, Ben Savage and Will Friedle.

NOW
"The worst is when people say, 'You look exactly the same,'" says Strong (far left). "Please tell me I've changed!"

● **RIDER STRONG**
Shawn Hunter
He's successful in movies (2003's *Cabin Fever*) and TV (*Pepper Dennis*), but Strong, 26, a magna cum laude Columbia grad and a published poet, hopes for an M.F.A. in writing. "Acting is my day job," he says. "Writing is my passion." Good friends with Will Friedle, he lives with his girlfriend in L.A.

● **DANIELLE FISHEL**
Topanga Lawrence
Fishel, 25, who lives with her boyfriend in Orange County, says it's been hard to get work because "I still look pretty young, but too old to play a high school kid." Still, she looks back happily: "I met a woman who named her daughter Topanga. I had one of the most awesome character names in TV history."

● **BEN SAVAGE**
Cory Matthews
After the show ended, Savage, now 25 and single, went to Stanford, where he got a degree in political science. In '03 he interned with Sen. Arlen Specter. So is a career in politics in the future? "My heart is in acting, but never say never," says Savage, who recently bought a house in L.A. and shot a film, *Car Babes*.

● **WILL FRIEDLE**
Eric Matthews
"Some of the greatest people in my life were on the show," says Friedle, 29 and single. "It sounds trite, but we were a family." Later, "I did a bunch of failed shows. We all got lucky doing *Boy Meets World*." Now known for voice-overs (he's Ron Stoppable in *Kim Possible*), he's also contemplating culinary school.

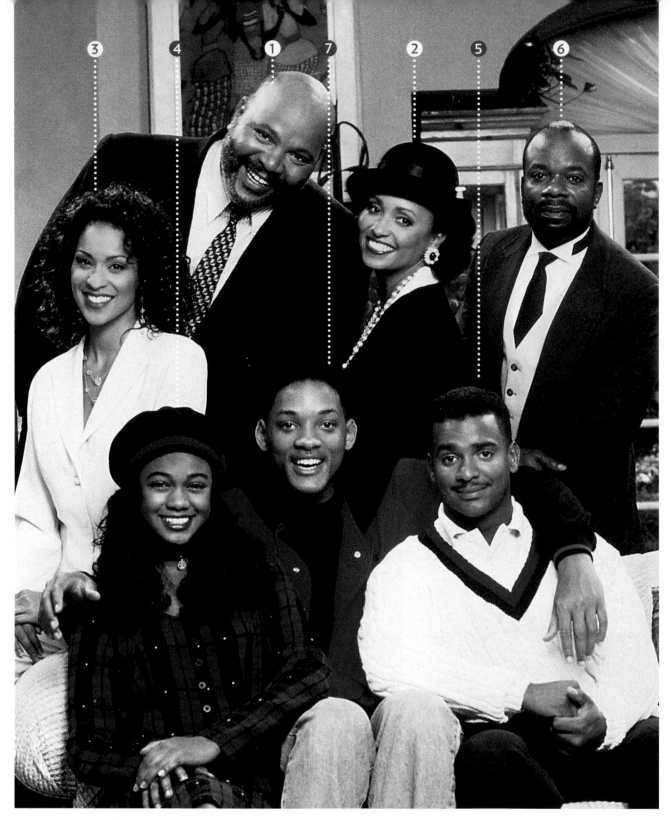

:THE FRESH PRINCE
:OF BEL-AIR 1990-1996

A poor kid from West Philly is exiled to live with rich relatives in L.A. Will Smith, rap's Fresh Prince, starred as the pauper in this culture-clash comedy, taking on poseurs and preppies, stereotypes and snobs. He left six seasons later a superstar

WHERE ARE THEY NOW?

1 JAMES AVERY
Philip Banks

His stentorian voice has served Avery, 57, in stage productions and as Shredder on *Teenage Mutant Ninja Turtles*. Fine with the grandpa of three: "You're only an actor when you're acting."

2 DAPHNE REID
Vivian Banks

"I was Aunt Viv down to my bones," said the second actress to play the role. And though Reid, 58, acts occasionally, she also runs a Virginia film studio with husband Tim Reid (*WKRP*).

3 KARYN PARSONS
Hilary Banks

The show's Valley Girl now produces kids' videos about African-American history. "I really believe in it," says Parsons, 38, who is married to filmmaker Alexandre Rockwell.

4 TATYANA ALI
Ashley Banks

After graduating from Harvard in 2002, "I had that 'What am I gonna do with my life?' feeling," says Ali, 27, who appeared in *Glory Road* and recorded a second R&B/pop CD.

5 ALFONSO RIBEIRO
Carlton Banks

He'll still do his *Fresh Prince* "snake" dance, but the show's preppy geek, now married with a child, has made a more graceful transition back to theater and directing.

6 JOSEPH MARCELL
Geoffrey

Since hanging up his butler's uniform, he's kept busy with stage and film work in Britain and the U.S., but his sitcom stint "kind of validated my career," says the married father of two.

SING ALONG WITH THE THEME SONG!

IN WEST PHILADELPHIA, BORN AND RAISED,
ON THE PLAYGROUND IS WHERE I SPENT MOST OF MY DAYS.
CHILLIN' OUT, MAXIN', RELAXIN' ALL COOL,
AND ALL SHOOTIN' SOME B-BALL OUTSIDE OF THE SCHOOL.
WHEN A COUPLE OF GUYS, WHO WERE UP TO NO GOOD
STARTED MAKIN' TROUBLE IN MY NEIGHBORHOOD
I GOT IN ONE LITTLE FIGHT AND MY MOM GOT SCARED
SHE SAID, 'YOU'LL MOVE IN WITH YOUR AUNTIE & UNCLE IN BEL-AIR!'

Big Willie!

7 WILL SMITH
Will Smith

"The whole energy of the sitcom world—I definitely miss that," said Smith, 37, upon returning to TV to produce the UPN series *All of Us*. Though the star of *Ali* and *Men in Black* is film royalty now, with wife Jada Pinkett Smith and three kids, "what's amazing is that Will is still the same guy," says castmate Ali.

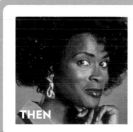

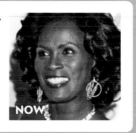

The First Aunt Viv

● **JANET HUBERT**

The Juilliard-trained actress left after Season 3 in a salary dispute with the network. Now 50 and the mother of a teenage son, she has a recurring role on *All My Children* and does voice-overs.

THEN

NOW

⦂TWIN PEAKS 1990-1991

Almost too surreal for prime time, this series from director David Lynch was set in the Pacific Northwest, but it really existed in its own parallel universe where kinky trysts, sinister conspiracies and supernatural occurrences abounded. The show's ambiguities intrigued—then exasperated—us. Yet *Peaks*, for all its maddening weirdness, still haunts our dreams

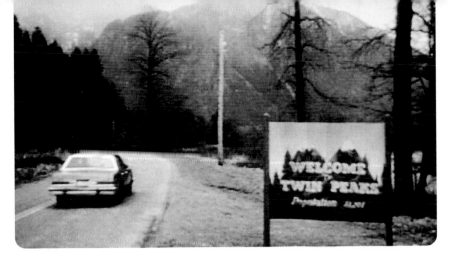

Did Anyone Understand This Show?

Still stumped about the dwarf? The owls? Killer BOB? Co-creator Mark Frost does his best to unravel Peaks's most vexing mysteries

So what the heck was all that about?
I have no idea. That's what was so odd about the show. We just threw stuff up from the subconscious every now and then. We didn't have any definitive meaning we wanted to impose on anyone. It was more of a Rorschach test for who the viewer was.

Still, we'd like to get your take on things. Let's start with the owls. What did they signify?
The owls were a particular way of hinting at a supernatural presence around Twin Peaks. They probably harked back to Native American legends. Also, in UFO-ology some people apparently claim that their memories of owls were a substitute for those of the little gray men who had actually abducted them. We came upon that in our reading and thought, "That's sort of interesting."

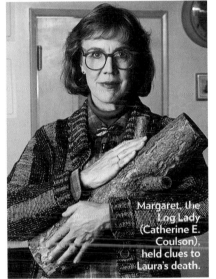

Margaret, the Log Lady (Catherine E. Coulson), held clues to Laura's death.

And the Log Lady?
She embodied the town's superstitious culture. In times past, they might have called her a witch, someone who had the ability to see beyond the veil of normal reality. David Lynch either had heard of or knew someone who carried a log around, and that became the touchstone for her telepathic visions.

Where did the idea of the dancing dwarf and the giant come from?

I remember David Lynch calling me up one day and saying, "Mark, there is a giant in Agent Cooper's room." I said, "Uhhh, okay. Well, let's try and figure out what he's doing there and go from there." We decided that the giant and the dwarf were both aspects of either an imaginary world dwelling within the mind of Laura's father, Leland Palmer (who turned out to be her killer), or of an alternate universe intruding on ours.

Who was "Killer BOB"?

That is the big question. Again, was Leland just insane and BOB a fragmented part of his personality? Or was BOB a real demonic presence? It's really hard to tell when you read accounts of genuinely irretrievable schizophrenics. They believe they are possessed.

What was behind having a pre-*X-Files* David Duchovny as a cross-dressing DEA agent, Dennis/Denise Bryson?
After we solved the Laura Palmer mystery, we needed another federal agent to come to town. I forget how we came up with a guy who was gender-confused. But David was hilarious in the role.

TV'S MOST FAMOUS CORPSE

The twin peaks of Sheryl Lee's career? Playing dead as Laura Palmer and as the original Mary Alice on Housewives

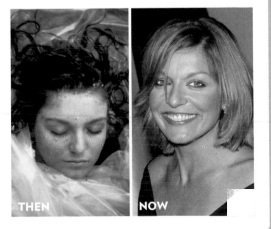
THEN NOW

● **SHERYL LEE** Laura Palmer/Madeleine Ferguson How did Lee, now 39, land the part of the slain homecoming queen? "We looked at her 8x10 head shot and thought, 'Yeah, she'd make a good-looking corpse,'" recalls producer Frost. (She later returned as Laura's look-alike cousin Maddy, who was also murdered.) In 2004, Lee won another part to die for—the deceased Mary Alice Young in *Desperate Housewives*. But after shooting the pilot, she was replaced by Brenda Strong because the producers thought Lee's tone was too ethereal. At least she's appreciated—and alive—on *One Tree Hill*, where she has a recurring role as Ellie Hart.

:MELROSE PLACE 1992-1999

Focusing on a group of twentysomethings living in an L.A. apartment complex, this *Beverly Hills, 90210* spinoff took catfighting and conniving to new heights. Its over-the-top story lines, ridiculous dialogue, crazy characters and trendy fashions became a gen-X benchmark. The show launched viewing parties, drinking games and countless fan sites, earning its rep as TV's hottest address for guilty pleasure

WHERE ARE THEY NOW?

1,2 DOUG SAVANT & LAURA LEIGHTON
(Matt Fielding & Sydney Andrews) They shared limited time on *Melrose*, but now Leighton, 37, and Savant, 42, share lives. With four kids (two from his first marriage) and his hit *Desperate Housewives*, "it's madness," he said, "but good."

3 DAPHNE ZUNIGA
Jo Reynolds
When the single Zuniga, 43, reunited with Grant Show on her series *Beautiful People*, "our first scene was in the doorway of an apartment building and I was having *Melrose Place* déjà vu all day long," she said.

4 JOSIE BISSETT
Jane Mancini
Bissett, 35, has written two parenting books and appeared in TV movies. The mom of two teamed with her husband, *Melrose* alum Rob Estes, for one, *I Do, They Don't*, about divorced parents who blend families. A year later they separated.

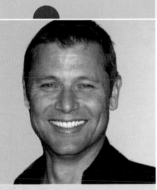
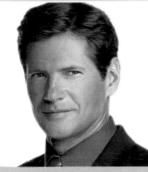
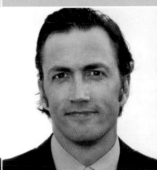
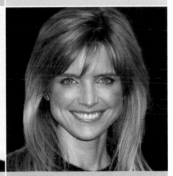

5 GRANT SHOW
Jake Hanson
"I think it's gonna help and hurt for the rest of my life," he said of his years playing the show's resident hunk. The married Show, 44, has signed on for a recurring role as Zuniga's ex-husband on *Beautiful People*.

6 THOMAS CALABRO
Dr. Michael Mancini
The only cast member to reside at *Melrose Place* for all seven seasons, Calabro, 47, followed the show with a slew of TV movies. Married with three children, he most recently appeared in a guest role on FX's *Nip/Tuck*.

7 ANDREW SHUE
Billy Campbell
A father of three, Shue, 39, quit acting in '98 to focus on Do Something, the youth service group he cofounded. "I didn't have [showbiz] in my blood," he has said. "I had this thing that I could give back to the world."

8 COURTNEY THORNE-SMITH
Alison Parker
She struck gold again with *Ally McBeal* and *According to Jim*, but Thorne-Smith, 38, wasn't so lucky in love. After a brief marriage and another engagement, she's starting over with her new fiancé, agent Roger Fishman.

TV'S Favorite Vixen

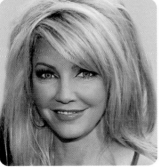

9 HEATHER LOCKLEAR
Amanda Woodward
With the series struggling in its second season, producer Aaron Spelling turned to his favorite agent provocateur (he'd cast her as Sammy Jo on *Dynasty*) to inject a bit of devilish fun. It worked. Later, Locklear, 44, scored again with *Spin City*. Now if she could just work her magic on her love life. "Perfect doesn't really exist," she told the AP before she split from husband Richie Sambora. "There's no perfect man."

WORST WACKO

MARCIA CROSS
Dr. Kimberly Shaw
Cross's character (1992-97) tried to kill her lover, stole a baby, bombed the complex and attempted suicide—all before dying of an aneurysm. Now the *Desperate Housewives* star is planning a wedding to investment banker Tom Mahoney.

4 5 1 2 3

:ROSEANNE
1988-1997

Mom and Dad fought, money was always tight, and the kids were told to go play in traffic. When it wasn't thumbing its nose at the stereotypical TV family, *Roseanne* managed to wring laughs out of serious subjects like infidelity and racism. Based on "domestic goddess" Roseanne Barr's caustic stand-up act, the groundbreaking series stuck around for nine seasons. Equally loud and loving, the Conners shone a spotlight on the struggles of working-class families aspiring to the American Dream

WHERE ARE THEY NOW?

1 JOHN GOODMAN
Dan

This year, the New Orleans resident (and married father of a teenage daughter) participated in a tourism campaign to boost the hurricane-ravaged city's economy. Of *Roseanne*, Goodman, 54, said, "It would be super if we could have some kind of reunion show. People would love it."

2 LECY GORANSON
Becky

The show "was a lot of pressure for me," she told Reel.com, "because I was young and I didn't have that maturity to take on some of that pressure." The single Goranson, 32, left for college in '93, returned for the '95-'96 season, then left again for theater and films, most recently *Love, Ludlow*.

3 SARA GILBERT
Darlene

"It would have been miserable to have a normal adolescence," Gilbert, 31, told ENTERTAINMENT WEEKLY. After the show, she earned an art degree from Yale and took recurring roles on *24* and *ER* before headlining The WB's *Twins*. She and partner Allison Adler have a son.

4 MICHAEL FISHMAN
D.J.

"Michael had comedic timing even at 6," Barr said. Fishman, 24, followed the show with small parts on TV, married and took time off to stay home with his two children. Now? "I am trying to come up with ideas for shows," he told Larry King. "I would do another show in a heartbeat."

THE OTHER BECKY

THEN NOW

● **SARAH CHALKE**
When she replaced Goranson as the Conners' oldest daughter in '93, she told ENTERTAINMENT WEEKLY, "There are people who don't even know a change was made." After the show, Chalke, 29, made indie and TV movies, landing NBC's *Scrubs* in 2001.

Makeover of the Decade

5 ROSEANNE BARR

Can this be—to quote the title of her 2003 reality show—the real Roseanne? The grandmother of two, 53, is now a pretty hot mama, thanks to plastic surgery and a gastric bypass that helped her shed 80 lbs. "When I look at reruns of my show with my son Buck [Thomas, 10], he goes, 'Mom, did you know you were that fat?'" she said. "I had no idea I was that fat." Back doing stand-up, where she started, she's also singing on a kids' DVD, *Rockin' with Roseanne*. Though not married (she and third husband Ben Thomas divorced in 2002), she's been with her current boyfriend, musician Johnny Argent, 57, since they met in 2002 after he posted children's songs on her Web site. "He's a good person, very ethical and calm," she told Britain's *Daily Mirror*. "And he's older than me. He's my first old boyfriend."

Who SAID IT?

Reunite these TV stars with their catchphrases

THE TRUTH IS OUT THERE. ❶

Did I do thaaat? ❸

D'oh! ❷

Oh my God, they killed Kenny! ❹

A

JALEEL WHITE
Family Matters

B

DAVID DUCHOVNY
The X-Files

C

HOMER SIMPSON
The Simpsons

D

MATT LeBLANC
Friends

E

DWAYNE JOHNSON
WWF Wrestler

F

GIDGET
Restaurant Ads

Is that your final answer? ⑤

BAM!!! ⑥

Sweetie darling. ⑦

Do you smell what The Rock is cooking? ⑧

Talk to the hand. ⑨

¡YO QUIERO TACO BELL! ⑩

You eeeeediot!!! ⑪

HOW YOU DOIN'? ⑫

REGIS PHILBIN
Who Wants To Be A Millionaire

MARTIN LAWRENCE
Martin

STAN MARSH
South Park

JENNIFER SAUNDERS
Absolutely Fabulous

EMERIL LAGASSE
Emeril

REN HOEK
The Ren & Stimpy Show

HOT TICKETS

That doomed cruise ship crashed through box office records, but '90s movies weren't all big budgets and special effects …

● **LEONARDO DiCAPRIO**
Jack Dawson
Now 31, he recently wrapped *The Departed* with director Martin Scorsese.

No. 1
MOVIE OF
ALL TIME
*grossed $1.835
billion worldwide
and earned
11 Oscars*

:TITANIC 1997

If ever a film lived up to its title, it was this Oscar-winning epic—from its $200 million-plus final budget, to its 17-million-gallon special-effects water tank, to its ranking as the all-time box office champ. The tale of star-crossed lovers aboard an ill-fated ocean liner managed to leave all previous blockbusters in its wake

WHERE ARE THEY NOW

● BILLY ZANE
Cal Hockley
Zane, 40, has worked steadily in B-movies, but his latest role, playing a brutal CIA operative in Iraq, has drawn fire. "I didn't think it would be taken as a broad insult to our men and women in uniform," he told *Newsweek*.

● FRANCES FISHER
Ruth DeWitt Bukater
Rose's haughty mother, Fisher, 54, has most recently focused on stage work in L.A. Offstage, she's a single mom to Francesca, 12, her daughter by ex-lover Clint Eastwood. "We're a good, big, extended family," says the actress.

● GLORIA STUART
Old Rose
The oldest-ever Oscar nominee, now 96, went on to do TV guest shots and co-author a '99 memoir. She now publishes art and culture books. With 12 great-grand-children, her goal, she says, is "to keep acting and to go peacefully."

● DANNY NUCCI
Fabrizio DeRossi
Jack's buddy, Nucci, 37, fell for second wife, actress Paula Marshall, when both appeared on the short-lived series *Snoops* in '99. Nucci, a father of two daughters (one from his previous marriage), has done guest shots on *Joey* and *House*.

WHAT BECAME OF ROSE'S NECKLACE?

Tossed overboard onscreen, the Heart of the Ocean still shines

Director Cameron invented the fictional bling and says "a bunch of cheesy knockoffs" were used during filming. Some have ended up in museum displays. But in 1998 jewelers Asprey & Garrard auctioned their own 170-carat Heart of the Ocean diamond necklace for $2.2 million to an anonymous bidder.

Celine's Heart Goes On

Dion has brought the theme she sang for* Titanic *to Vegas

The first time she sang "My Heart Will Go On," "I had tears in my eyes," Dion said in 1998. It's now her closing number at Caesars Palace in Las Vegas, where the chanteuse, 38, celebrated her 500th performance in May. After her contract ends in December 2007, she, manager husband René Angélil, 64, and their son René-Charles, 5 (who was conceived through in vitro fertilization in 2000), will move to their Jupiter, Fla., home. Look for more kids in the family. "I want to be more successful as a mother," she told *USA Today*, "than as a singer."

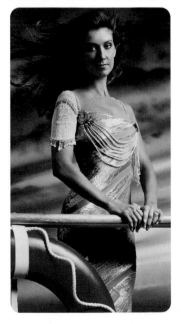

JAMES CAMERON:
On Being 'King of the World' and *Titanic's* Other Ending

Nietzsche said, "What doesn't kill you makes you stronger." I never thought *Titanic* would kill me. At one point I did think it might be career suicide and that I might be lucky to get a Black & Decker commercial afterwards. That was during post-production. The media frenzy was building up. After a private screening, my second-unit director said, "I think you ought to cut the ending. You just want to stay with the Jack and Rose story and you should get rid of all that stuff set aboard the salvage ship." He was right. That particular five-minute scene was with Bill Paxton and my soon-to-be wife, Suzy Amis. [They see Old Rose climbing the ship's railing to throw the diamond necklace into the ocean and rush to stop her.] I always joke that I cut Suzy's part down to a quarter of what it originally was. She somehow still married me. It must be love.

There wasn't really a post-*Titanic* let down for me. Its success gave me financial and creative security. I could do whatever I wanted. Right now, we're working on *Project 880*, a big science-fiction story set on an alien planet with lots of weird creatures.

People still ask me about where *Titanic's* most famous line came from. I was in a crane basket about 100 feet above Leo, who was on the ship's bow set. We were doing these pass-bys so it looked like the ship was moving, and I was feeding him ideas via walkie-talkie. I said, "Try one where you close your eyes." But it wasn't what I wanted. So I said, "Try one where you say, 'I'm the king of the world!'" And Leo said, "What?" I was like, "Just try it, I think it will work." It worked perfectly. I really liked that moment.

Cameron (in '98) used the "I'm the king of the world" line to express his elation at winning the Best Director Oscar.

THEN
From left: Stacey Dash,
Alicia Silverstone and
Brittany Murphy.

CLUELESS 1995

Bettys and Baldwins, Val gals, skater dudes and one proudly picky virgin. What*ever!*
With razor-sharp satire and pitch-perfect teenspeak, director Amy Heckerling's exuberant
skewering of life among privileged L.A. high schoolers was as smart and witty as its
inspiration, Jane Austen's classic novel *Emma*—and as bright and frothy as the designer
duds worn by its fabulously pampered heroine

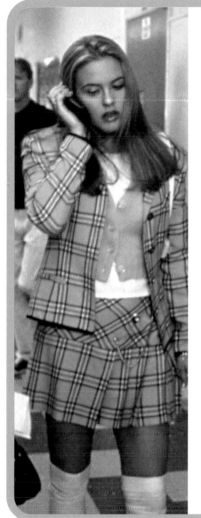

WHAT WOULD CHER WEAR?

Teen queen Cher Horowitz inspired real fashion trends

● Though grunge was all the rage in 1996, "we wanted to bring the femininity of girls to the screen and create something unusual and fresh for kids to emulate," said *Clueless* costume designer Mona May, who created Cher's 56 outfits. Emulate they did: Thigh-high tights, wide headbands and lots and lots of plaid soon caught on as chic, high school girl-on-the-go wear. "When the movie came out," said May, "I was able to see the impact myself. I was amazed."

Mixing Valley Girl slang with pop-culture smarts, the film launched a whole new language

AS IF! *interj.* An expression of utter disgust or repulsion.

AUDI *adv.* Denotes the leaving of a setting or location. A variation on "We're outta here," e.g., "We're Audi!"

BETTY *n.* An attractive female, from Betty Rubble of *The Flintstones.*

BALDWIN *n.* A good-looking guy. See Baldwin brothers Alec, Billy, Stephen and Daniel. Okay, not Daniel.

BARNEY *n.* A generic, unremarkable male, à la Betty's *Flintstones* husband, Barney.

BUGGIN' *adj.* Freaking out, overreacting.

CHECK IT! *imper.* Listen up! A heads-up that new information will follow. Most often used during gossip sessions.

LOADIE *n.* A drug user.

MONET *n.* Someone who is good-looking from a distance but a mess up close, e.g., "She's a total Monet."

JEEPIN' *gerund* The act of fooling around in the back seat of a car. Also known as vehicular sex.

NICE PILE OF BRICKS *n.* An impressive house.

SOLID *adj.* The state of being on the same wavelength; a declaration that no rift has occurred in a relationship, e.g., "We're solid."

TSCHA! *interj.* "Surely you jest!"

WHATEVER! *interj.* Ubiquitous passive-aggressive response to questions, demands, simple declarative sentences, whatever! . . .

WHERE ARE THEY NOW

● **ALICIA SILVERSTONE** Cher Horowitz
After a post-*Clueless* misstep as Batgirl in the '97 flop *Batman & Robin,* Silverstone, now 29, turned to the small screen, appearing in the '03 sitcom *Miss Match* and landing the lead in a comedy pilot for ABC. Wed to musician Christopher Jarecki, the longtime animal rights activist has said she's happiest "as a weird, dorky girl who just hangs out with her dog."

● **BRITTANY MURPHY** Tai
After her screen makeover, the film's ugly duckling saw her career blossom into roles in more than 20 films, including *Just Married* (with ex-boyfriend Ashton Kutcher) and *8 Mile.* For the actress, now 28 and engaged to movie best boy grip Joe Macaluso, *Clueless* "brings nothing to my mind but exciting times and happiness," she says.

● **STACEY DASH** Dionne
"I've not had such a good experience on a film since," said Dash, 39, who reprised her role in the *Clueless* TV series. No surprise there: The actress met husband Brian Lovell, an electrician, on the set.

FORREST GUMP 1994

It was the epic story of a plain and simple man who unwittingly found himself central to some of the 20th century's most defining moments, from the civil rights movement to Watergate. Based on the 1986 novel by Winston Groom and spun from homey aphorisms, the ode to innocence resonated with nostalgia-hungry audiences, making it the year's top-grossing film and earning it six Oscars, including Best Picture and Best Actor

Everybody Loves Tom

The movie star next door is proof that nice guys sometimes finish first

● **TOM HANKS**

When *Forrest Gump* opened, TIME anointed the then-37-year-old Hanks "Hollywood's last decent man." A two-time Oscar winner, he's also one of its most celebrated. While still commanding big-budget films like *The Da Vinci Code,* Hanks also directs and produces (HBO's acclaimed miniseries *Band of Brothers*). Stardom for stardom's sake was never the point. "I would've made *Forrest Gump 4* by now," he told ENTERTAINMENT WEEKLY. "And what would have been the excitement or the art or the newness of that?"

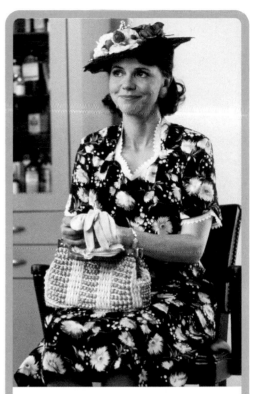

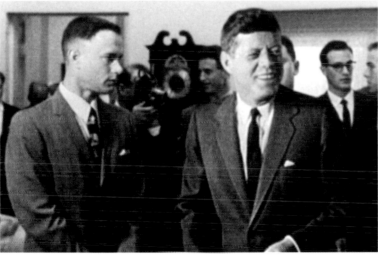

HOW DID THEY DO THAT?

Forrest left his mark on history, thanks to digital magic that inserted his image into archival footage of John F. Kennedy, John Lennon and others.

The Bubba Gump Shrimp Co.

The dream of Forrest's buddy Bubba Blue made the leap from reel to reality

Riding the wave of the film's success, Viacom Consumer Products (a division of Paramount Pictures owner Viacom) and Rusty Pelican Restaurants launched what would become the first dining chain based on a movie, in Monterey, Calif., in 1996. The menu features favorites like Mama Gump's Garlic Bread Basket and Bubba's Far Out Dip, and the all-*Gump* decor spotlights reproductions of script pages, costumes, still photos and other memorabilia. There are now 21 restaurants worldwide.

MAMA ALWAYS SAID...

Forrest's tireless champion, Mrs. Gump (Sally Field, above) dispensed life's lessons with a few well-chosen words

"LIFE IS A BOX OF CHOCOLATES. YOU NEVER KNOW WHAT YOU'RE GONNA GET."
"STUPID IS AS STUPID DOES."
"YOU HAVE TO DO THE BEST WITH WHAT GOD GAVE YOU."
"DEATH IS JUST A PART OF LIFE, SOMETHING WE'RE ALL DESTINED TO DO."
"YOU'VE GOT TO PUT THE PAST BEHIND YOU BEFORE YOU CAN MOVE ON."
"MIRACLES HAPPEN EVERY DAY."

RICHARD GERE

He starred in more than a dozen films after *PW* but is now best known for his humanitarian work with the Dalai Lama. He and his wife, actress Carey Lowell, have a son.

PRETTY WOMAN 1990

It was a modern fairy tale: A handsome prince (corporate raider) woos a fair maiden (street-smart call girl hired to pose as his girlfriend), and they fall in love. Putting a neofeminist spin on the hooker-with-a-heart-of-gold conceit, the box-office-busting romantic comedy tugged at heartstrings while lampooning the superficial L.A. lifestyle. It also officially kicked off the reign of America's Sweetheart

NOW

QUEEN JULIA

The smile. The box office success. The staying power.
The star of the decade is still No. 1

● "Julia has a magic up there on the screen," said director Garry Marshall. "After her screen test, I said, 'We're going to make it with this girl. She's got it.'" Roberts, 38, has continued to dazzle, winning an Oscar for 2000's *Erin Brockovich* (in which she became the first actress ever to be paid $20 million for a movie) and embracing home life (at a New Mexico ranch and Manhattan apartment) with cameraman husband Danny Moder, 37, and twins Phinnaeus and Hazel, 1½. In 2006 she made her Broadway debut in *Three Days of Rain*, opening to sellout crowds.

Julia's Body Double

She was the legs (and some other parts) behind the Pretty Woman

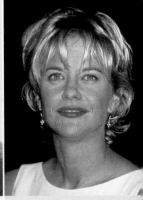

● That wasn't Julia Roberts on *Pretty Woman*'s famous poster: It was professional body double Shelley Michelle. "They wanted somebody with curvier, sexier legs," she says. Michelle was paid just $750 a week but went on to sub for Kim Basinger and Madonna— and to form her own agency, Body Doubles and Parts. (She became pregnant with her daughter Michelle at the same time Roberts was expecting her twins.)

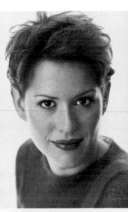

"Julia thanked me every day," says Michelle, now 44.

THEY TURNED DOWN THE ROLE

As Vivian herself might have said, 'Big mistake. Big. Huge!'

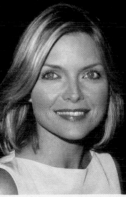

MICHELLE PFEIFFER

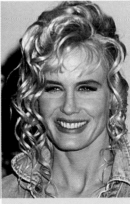

DARYL HANNAH

MOLLY RINGWALD

MEG RYAN

SCREAM 1996

Credited with reviving the horror genre, *Scream* became an instant smash, mocking conventions of slasher films like *Halloween* and *Friday the 13th* as it killed off its sexy young cast. Grossing $103 million on an $18 million budget, it generated two sequels and a slew of parodies and made post-*E.T.* Drew Barrymore a household name once again

Q&A: WES CRAVEN

Making Scream *was a scream for the master of suspense*

Why kill off Drew Barrymore? Drew already had a big fan base. No one expected us to kill off the cute *E.T.* girl. And then we knocked her off in the first 15 minutes! It gets your attention. It sent the message: This is not a predictable film.

But you decided not to kill off David Arquette. We offered him a lead role, but he insisted on playing Deputy Dewey, and he turned him into someone with off-the-wall wisdom. He was so likable that at the last minute we decided to let him live.

And then he and Courteney Cox got together. It's a great little story, that they fell in love making the movie. He would make her laugh. She would help him memorize his lines. They make a great couple. She got a little looser and he got a little straighter.

On breaking all the rules: *Scream* was clever in that it said up front, "This is a horror film." Jamie Kennedy's character Randy gives his list of rules of what should never be done in a horror film, and then the movie proceeds to break every rule.

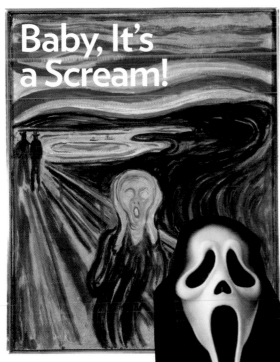

Baby, It's a Scream!

Now a Halloween costume staple, the killer's mask was inspired by Edvard Munch's masterpiece *The Scream.*

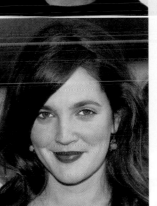

WHERE ARE THEY NOW

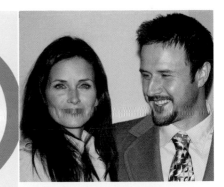

● **COURTENEY COX AND DAVID ARQUETTE**
Gale Weathers and Dewey Riley
"We realized pretty quickly we were falling for each other," says Arquette, 34, of working with Cox, 42. The two married in San Francisco in '99 and are now parents of 2-year-old daughter Coco Riley.

● **NEVE CAMPBELL**
Sidney Prescott
Trying to avoid typecasting as a "scream queen," Campbell, 32, quit horror roles—at least after *Scream 3.* Returning to her ballet roots, she starred as a dancer in Robert Altman's *The Company* in '03 and is engaged to actor John Light. "I was always going to be a dancer," she said. "I never expected a film career in the first place."

● **DREW BARRYMORE**
Casey Becker
"I wanted her to be deliciously sweet," said Barrymore of her role as the "candy-apple-eating girl" murdered by the serial killer in *Scream*'s opening scene. "Nobody wants to see bad things happen to a sweet person." Since then, Barrymore, 31, has starred in more than a dozen films, from *The Wedding Singer* to *Charlie's Angels.*

● **SKEET ULRICH**
Billy Loomis
With slicked-back hair and an intense gaze, Ulrich toed the line between heartthrob and brooding killer as Sidney's suspicious boyfriend. "It's hard to be afraid of your own movie, but I was," said Ulrich, 36, who has since steered clear of horror parts, recently starring in the miniseries *Into the West,* produced by Steven Spielberg.

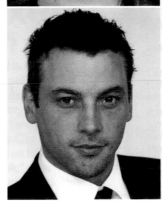

WAITING TO EXHALE 1995

Based on Terry McMillan's bestselling novel, *Exhale* was a warm look at four friends—starring Whitney Houston (Grammy-nominated for her soundtrack megahit "Exhale [Shoop Shoop]"), Angela Bassett, Lela Rochon and Loretta Devine—struggling to get a grip on their lives and loves. Giggly and tear-jerking by turns, this low-budget directorial debut by actor Forest Whitaker became a crossover smash, grossing more than $80 million worldwide

THEN
From left:
Loretta Devine,
Whitney Houston,
Angela Bassett
and Lela Rochon.

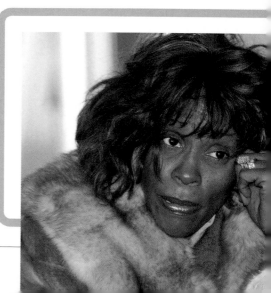

WHERE ARE THEY NOW?

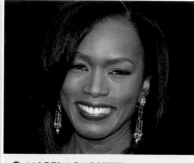

● **ANGELA BASSETT**
Bernadine "Bernie" Harris
With a new film, *Akeelah and the Bee*, Bassett, 47, shares the spotlight with twins Bronwyn and Slater, born via surrogate to her and husband Courtney B. Vance. "A friend told me Jesus was had by a surrogate, and I said, 'Thank you for that,'" she says.

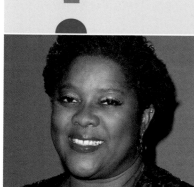

● **LORETTA DEVINE**
Gloria "Glo" Matthews
Devine, 56, has stayed busy with TV appearances on shows like *Everybody Loves Chris* and *Grey's Anatomy*; she's fit in roles in Oscar winner *Crash* and the upcoming *Dreamgirls,* as well as a long-term relationship with her fiancé, financial analyst Glenn Marshall.

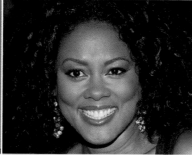

● **LELA ROCHON**
Robin Stokes
Wife of director Antoine Fuqua and mom of two, Rochon, 41, was glad to go AWOL for a while. "[My kids] are more important than any movie," she told *Essence*. Now, she's prepping for reentry in the drama *Running Out of Time in Hollywood*.

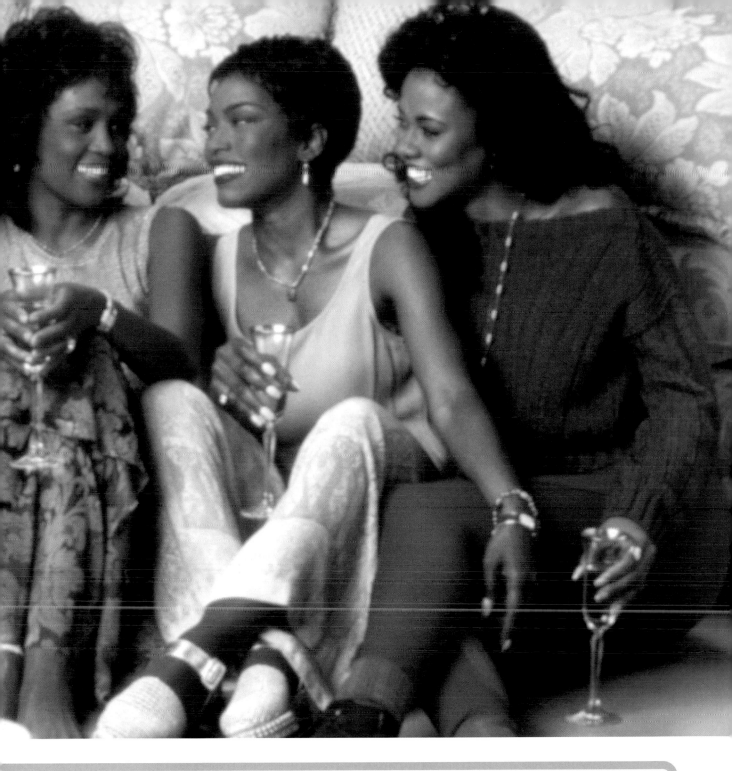

WHAT'S UP WITH WHITNEY?

The once-golden girl has been derailed by drugs and domestic violence

● After *Exhale,* Whitney Houston continued taking on roles in films like *The Preacher's Wife* (1996) and the TV movie *Cinderella* (1997) and rocketed to No. 1 with a post–9/11 reissue of "The Star-Spangled Banner." Yet whispers about her drug use grew. In 2000 she was caught with marijuana in a Hawaii airport. Then, in a 2002 interview with Diane Sawyer, thin and fidgety, Houston confessed that she had done drugs, but insisted, "I don't like to think of myself [as] addicted." In '03, police found Houston, now 42, bruised and cut after they were called to her Atlanta home; Bobby Brown, her husband of 14 years, was charged with a misdemeanor. Desperate to get Whitney to clean up her life for the sake of her daughter Bobbi Kristina, 13, mom Cissy Houston reportedly had her sent to rehab; a year later, in '05, the family's reality show *Being Bobby Brown* premiered to high ratings. But recently, sister-in-law Tina Brown told a tabloid that Houston spends days in crack houses or at home, dirty and disheveled, beating herself black and blue.

① ② ③ ④ ⑤ ⑧ ⑥ ⑦

FUN FACT!
The apple pie used in Jason Biggs's pastry love scene came from Costco.

AMERICAN PIE 1999

Lewd, crude and riotously funny, this suburban tale of four high school friends who make a pact to lose their virginity by prom night spawned three sequels, helped launch the careers of Chris Klein, Jason Biggs, Seann William Scott, Tara Reid and Mena Suvari, rewrote the rules of attraction and forever changed the way we looked at a favorite dessert

WHERE ARE THEY NOW?

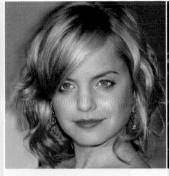

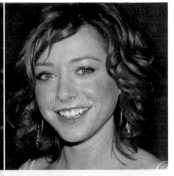

1 MENA SUVARI
Heather
Suvari, 27, followed *Pie* by getting serious in '99's Oscar-nominated *American Beauty.* "It's a career I'm interested in—not some kind of hot-celebrity-of-the-moment status," she has said.

2 CHRIS KLEIN
Chris "Oz" Ostreicher
Best known post-*Pie* for his busted engagement to Katie Holmes, Klein, 27, waxes philosophical: "Life is life. Mine has been nothing but the highest of highs and the lowest of lows."

3 ALYSON HANNIGAN
Michelle Flaherty
She stars in *How I Met Your Mother,* but to *Pie* fans, the *Buffy* alum will always be nerdy Michelle. "They shout out 'This one time, at band camp' at me across the mall," says Hannigan, 32.

4 EDDIE KAYE THOMAS
Paul Finch
Though he hasn't had a *Pie*-sized hit, Thomas, 25, has been busy, shooting three films in '05. "Long hours on the set are better than no hours on the set," he says.

5 JASON BIGGS
Jim Levenstein
Biggs, 28, won critical praise for his '02 turn as Benjamin Braddock in *The Graduate* on Broadway and has appeared in films like '06's *Eight Below.*

6 SEANN WILLIAM SCOTT
Steve Stiffler
After playing Bo Duke in '05's *Dukes of Hazzard,* Scott, 29, admits he worries about being typecast as a lunkhead: "I don't want [fans] to get sick of my face."

7 THOMAS IAN NICHOLAS
Kevin Myers
Along with acting work, Nicholas, 25, is recording a CD. "I play mainly acoustic guitar and write my own songs," he says.

Party Icon!

8 TARA REID
Vicky Lathum
Despite steady acting work, Reid, 30, is better known for her partying and her love life (she was engaged to Carson Daly) than for her acting. "I need one more great movie role so they say, 'Wow, she can act!'" she has said.

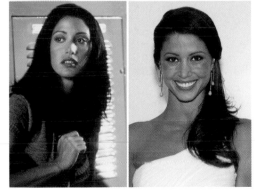

● **SHANNON ELIZABETH** Nadia
After her role as a sexy exchange student, Elizabeth, 32, proved she was more than a hot bod by playing the celeb poker circuit, holding her own in the '05 World Series of Poker.

:PULP FICTION

● 1994

If a movie could make violence and gore stylish, *Pulp Fiction*, written and directed by ex-video-store-clerk Quentin Tarantino, was it. Nominated for seven Oscars (it won Best Original Screenplay), this wild, funny, chronologically chaotic nod to noir and pop culture reignited its stars' careers and made Tarantino an instant indie hero

WHERE ARE THEY NOW

● JOHN TRAVOLTA

Vincent Vega Talk about staying alive! His oddly simpatico performance in *PF* as a hit man who could do the twist revived Travolta's appeal and put him on an acting track that included brilliant turns in films such as *Get Shorty* (1995) and *Primary Colors* (1998). The actor, 52, said of his upcoming memoir, "I've had such a full life that I really want to share it."

● SAMUEL L. JACKSON

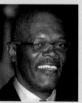

Jules Winnfield Once a bit-part player, Jackson was suddenly hot after his Oscar nod for *PF*. Now 57, he went on to appear in a string of hits, including three of Hollywood's highest-grossing films (he created the character of Mace Windu in the *Star Wars* prequels), and provided the voice of the ice-generating Frozone in the 2004 blockbuster *The Incredibles*.

● UMA THURMAN

Mia Wallace Now 36, Thurman reunited with Tarantino for his yakuza-inspired duo *Kill Bill 1* and 2 (2003, 2004) and won praise for her role in *The Producers* (2005). Her personal life, though, had downs as well as ups: In 2003 she split from her husband, actor-novelist Ethan Hawke, 35, with whom she has two kids; later that year, she began an on-again, off-again relationship with hotelier André Balazs.

THE *PULP FICTION* DANCE

John Travolta and Uma Thurman twisted their way into movie history

● **Instant classic:** A coked-up Mia (Thurman) coerces a reluctant Vincent (Travolta), her husband's hit man, onto the floor at an L.A. '50s theme restaurant called Jack Rabbit Slim's and orders him to help her ace the twist contest (to Chuck Berry's "You Never Can Tell"): "Now I wanna dance, I wanna win. I want that trophy, so dance good."

How good? ABC film critic Joel Siegel put the scene at No. 2 on his 2005 list of Hollywood's Best Dancing on DVD, below only *Dirty Dancing* and beating out *West Side Story* and *That's Entertainment.*

Inspiration: Thurman reportedly based her dancing on the character Duchess in Disney's 1970 animated film *The Aristocats*; Travolta has said he got ideas from TV Batman Adam West's jerky "Batusi" moves on the '60s show.

Influence: Director Quentin Tarantino (inset), obsessed with French film auteur Jean-Luc Godard, was inspired by a café scene in the 1964 Godard movie *Bande à Part* (he named his production company for it too), where the dancers move in a mechanical, puppetlike way.

Imitation: The best is from another modern classic: *The Simpsons.* Tarantino was the special guest director of an episode in which mouse and cat Itchy and Scratchy twist again in front of a cartoon Tarantino's decapitated corpse.

Internet: Get down with Travolta right here: tvdance.com/pulpfiction/

Bible-spouting assassin Jules (Jackson, right) and co-goon Vince (Travolta) get ready for a job: "Come on," says Jules. "Let's get into character."

● **BRUCE WILLIS**

Butch Coolidge *PF* put Willis back on the map after a slump; he went on to star in big-screen smashes such as *Armageddon* (1998) and *The Sixth Sense* (1999). Of *Lucky Number Slevin,* Willis, 51, says, "It's being compared to *Pulp Fiction*—it's like an homage." In 2000, Willis divorced wife and mother of their three daughters Demi Moore, 43, who wed actor Ashton Kutcher, 28, in '05.

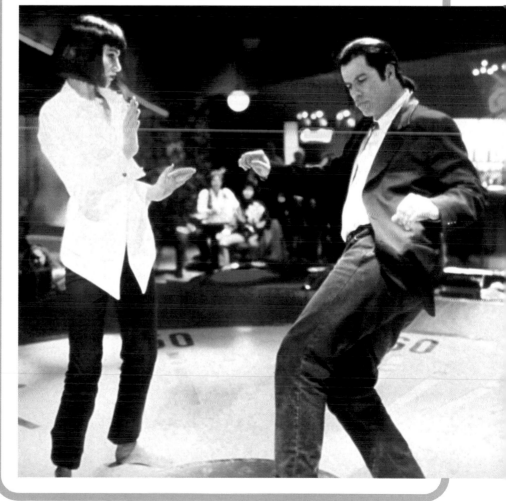

The chilling raptors-in-the-kitchen scene was shot on Joseph Mazzello's 9th birthday (he's below, with Ariana Richards, then 13). "The raptors are very intelligent and cooperative in their attack," Spielberg explained. "And that in itself is scary."

JURASSIC PARK
1993

Secret experiments, a spooky jungle theme park—plus hordes of stomping, spitting dinosaurs that redefined special effects—helped make Steven Spielberg's film of the Michael Crichton sci-fi thriller a Tyrannosaurus-sized hit. The jeep-chomping *T. rex* and vicious velociraptors hatched two sequels—and ensured that no paleontology exhibit would ever seem benign again

Dino Might

Merging new technology with storytelling technique, Steven Spielberg created a whole new animal

Never before had technology and cinematic art come together as they did in *Jurassic Park*'s breakthrough development and use of Oscar-winning computer-generated imagery (CGI). Developed over three years by director Steven Spielberg's team and the wizards at George Lucas's Industrial Light and Magic (the force behind *Star Wars*), the film's scientifically accurate CGI brought the Jurassic Age into shockingly detailed close-up—and danger had never looked so good. The malevolent twitch in *T. rex*'s eye and reptilian cunning of the razor-toothed velociraptors had viewers as mesmerized as they were petrified. "I never thought I wanted to do a dinosaur movie better than anyone else's," said Spielberg. "But I did want my dinosaur movie to be the most realistic of them all."

WHERE ARE THEY NOW?

● **ARIANA RICHARDS** Lex Murphy
The child actress who played the computer-hacking granddaughter of Jurassic Park's founder John Hammond still lives in L.A. But at 26, Richards has given up the movie biz for now. After high school, the budding painter headed for Skidmore College to study fine art and drama. Now flourishing as a portrait artist, she sells her work in high-end California galleries. "I've been swept up in this whole art thing," she says. "It just took off like crazy." Like her *Jurassic* little brother, Joseph Mazzello, she remains in touch with director Steven Spielberg. "He still sends me a Christmas present every year," she says. "He's very generous."

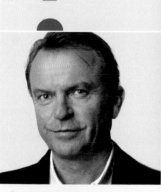

● **SAM NEILL**
Dr. Alan Grant
He played a paleontologist who disliked kids. In reality, Neill, 58, is dad to three and lives in Australia with wife Noriko Watanabe. Though he continues to act, Neill claims he's happiest tending his three small vineyards.

● **LAURA DERN**
Dr. Ellie Sattler
Now 39, Dern has shifted her focus to her two children—Ellery, 4, and Jaya, 19 months—with blues rocker Ben Harper. "For the first time in my life, everything makes sense," the actress has said.

● **JOSEPH MAZZELLO**
Tim Murphy
The 2005 grad of the University of Southern California is, at 22, directing as well as acting. Spielberg wrote his referral for film school, "the best recommendation a human could ask for!" said Mazzello.

● **JEFF GOLDBLUM**
Dr. Ian Malcolm
After starring in two of the decade's biggest films (*Park* and *Independence Day*), Goldblum, 53, has lately been concentrating on the stage, appearing on Broadway in the dark comedy *The Pillowman*.

REALITY BITES 1994

It was supposed to be just another romantic comedy, but this knowing, bitingly funny look at the aimless frustration of twentysomethings edging warily toward adulthood became a cult classic that defined generation X

"My character is very close to what I would probably have ended up as if I hadn't become an actress," said Winona Ryder of playing *Reality*'s would-be filmmaker.

WHERE ARE THEY NOW

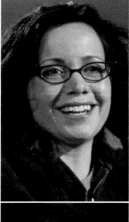

● **JANEANE GAROFALO**
Vickie Miner
In *Reality* she was stuck managing a Gap store, but now, at 41, the longtime stand-up comic and ardent liberal reports to her dream job: cohosting a nightly radio talk show on left-leaning Air America.

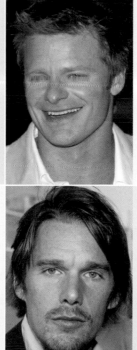

● **STEVE ZAHN**
Sammy Gray
The film marked his breakthrough as the funny sidekick, and though Zahn, 38, a father of two, admits he'd like to try a leading-man role, he's not complaining. Acting is still "a big, fun party. I laugh at people who complain about it."

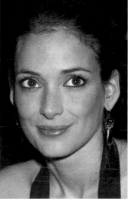

● **WINONA RYDER**
Lelaina Pierce
Though a 2002 shoplifting conviction sidelined her career for a while (she made restitution and successfully completed three years' probation), Ryder, 34, returns to movie screens this year in the futuristic animated drama *A Scanner Darkly*.

● **ETHAN HAWKE**
Troy Dyer
He juggles movies, stage work and fiction writing (he has published two novels) and helps raise his two kids with ex-wife Uma Thurman. And Hawke, 35, wouldn't have it any other way: "I couldn't just do the same thing for my whole life."

Real(ity) World

When Winona Ryder, as aspiring filmmaker Lelaina Pierce, sets out to chronicle the lives of her friends, she was channeling the first season of MTV's *The Real World*. Jumpy editing, late-night philosophizing, drugs, jokes, sex—it's all there in all its grainy integrity. Appalled when her footage is turned into a brash, MTV-worthy docudrama, Lelaina might have felt better had she known this: *Real World* just wrapped its 17th season.

Behind the Camera

● First-time director Ben Stiller, 40, who cast himself as ambitious media exec Michael, went on to become a comic powerhouse in films like *There's Something About Mary* and *Meet the Parents*. He is the father of two children, Ella, 4, and Quinlin, 2, with his actress wife, Christine Taylor.

LISA LOEB

She wrote the song that summed up a generation

● Through her trademark horn-rimmed glasses, Lisa Loeb looks back on *Reality Bites* "in the best of ways," says the singer-songwriter of the film's hit song "Stay (I Missed You)." With its video directed by her pal Ethan Hawke, "Stay" went to No. 1, earning Loeb a record deal. Six studio albums later, it's still the most-requested tune at her concerts: "I play it at every show." After starring in a 2004 Food Network show with then-boyfriend Dweezil Zappa, Loeb, 38, now appears in E!'s *No. 1 Single*, which documents her reentry into the dating pool for the first time since the early '90s. What's changed since then? "We have totally different hair products—and shoes."

Who SAID IT?

Test your movie memory by pairing the faces with their famous lines

You guys give up yet? Or are you thirsty for more? **1**

TO INFINITY AND BEYOND! **2**

Party on, Wayne! **3**

You had me at hello. **4**

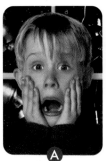

A

MACAULAY CULKIN
Home Alone

B

TOM HANKS
Apollo 13

C

RENEE ZELLWEGER
Jerry Maguire

D

BUZZ LIGHTYEAR
Toy Story

E

ARNOLD SCHWARZENEGGER
Terminator 2: Judgment Day

F

MIKE MYERS
AUSTIN POWERS: International Man of Mystery

LET'S KICK SOME ALIEN BUTT! ⑤

Hasta la vista, baby. ⑥

YOU CAN'T HANDLE THE TRUTH! ⑦

Houston, we have a problem. ⑧

SSSSMOKING! ⑨

I ate his liver with some fava beans and a nice chianti. ⑩

YOU'RE SO MONEY! ⑪

Oh, behave! ⑫

WILL SMITH
Men in Black

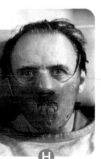

ANTHONY HOPKINS
The Silence of The Lambs

VINCE VAUGHN
Swingers

DANA CARVEY
Wayne's World

JACK NICHOLSON
A Few Good Men

JIM CARREY
The Mask

Answers: 1. A; 2. D; 3. J; 4. C; 5. G; 6. E; 7. K; 8. B; 9. I; 10. H; 11. L; 12. F

POP, RAP

From girl power and boy bands to hip-hop and country, music rocked, rapped and all-around got jiggy

Victoria Beckham
Posh

She married soccer phenom David Beckham in '99. Now 32 and mom of three, she has a line of jeans for Rock & Republic.

Geri Halliwell
Ginger

Now 33, she gave birth to her first child, a daughter, in May '06. Dad is scriptwriter Sacha Gervasi.

Melanie Chisholm
Sporty

"Mel C," 32, started a record label, Red Girl, and debuted a new sound: "tougher, edgier, with loads of guitars."

On top of the world: Posh, Ginger, Sporty, Baby and Scary (in May 1997) had No. 1 hits in 51 countries.

&ROLL

SPICE GIRLS

● Their slogan "Girl Power!" became a rallying cry for a million teens, inspiring Beatlemania-style hysteria. Selling more than 55 million albums, the British imports became one of the most popular acts in the 20th century. Their spinoffs included a movie, *Spice World*, and a line of dolls. Their '96 breakout song "Wannabe" ("Tell me what you want, what you really, really want!") produced a fan base that ranged from tweens to drag queens. But in '98 Halliwell left the group and they last recorded in 2000. After a failed reunion attempt for the Live 8 concert in '05, the girls seem closer than ever. "We're always on the phone," says Bunton (a.k.a. Baby Spice). "We talk about boys—girlie stuff."

Mel Brown
Scary

"Mel B," 31, followed a stint in *Rent* on Broadway with an album, *L.A. State of Mind,* inspired by her new hometown, where she lives with daughter Phoenix, 6.

Emma Bunton
Baby

After a Bollywood role and an album, *Free Me,* in '05, Bunton, 31, added charity work for the Prince's Trust to her credits.

:BOY BANDS

How to separate the boys from the men? The boys had unthreatening charm and mean dance moves. They were as adorable and energetic as puppies, but when it came to record sales, these pups were alpha dogs

'N SYNC

● Initially mocked as Backstreet wannabes, the fab five (here in '98) spent two years conquering Europe before the U.S. flipped for their eponymous 1998 debut, a blue-eyed blend of pop, rock and R&B.

Joey Fatone

At 29, a married dad and a Broadway vet (*Rent*), he's venturing into films. "Things couldn't be better," he says.

Lance Bass

Having trained with NASA, he'd still like to head into space, but acting, says Bass, 27, "is what I want to do now."

Justin Timberlake

'N Sync's solo star, 25, has hit records, film roles, a clothing line and Cameron Diaz for a girlfriend.

Chris Kirkpatrick

The oldest member, 34, has kept the lowest profile, starting a clothing line and producing other music acts.

I Survived a Boy Band

*by JC Chasez, 29,
member of 'N Sync*

● Actually, I loved it. We were so young, we were like sponges—we were really able to appreciate it. We lived a dream, a full life in a matter of years. In South Africa, we got to go swimming in two oceans, the Indian and Atlantic, within an hour. In a boy band, in terms of imagination, the sky was the limit. Other genres worry about looking cheesy. But if we could think it, we tried it. If there was a new product, we'd stick it in our hair. If there was something ridiculous to wear, we'd wear it because we thought it was cool to stand out. We were so excited about being onstage, we'd wear snakeskin pants when we were in our hometowns with everyone else in khaki pants.

But we never went crazy in our personal lives. I know a lot of bands, and their problem is, they lose respect for each other. We're not a band anymore, but we still respect each other, and that's why we stayed friends. Everybody remained humble. And when you're a solo artist, you have to eat humble pie again. With my next solo album, out later this year—the writing's done, I'm in the production phase—it's definitely still pop, it's stuff you can dance to, but everything's guitar-based.

It's lonely when you're a solo artist—people say they can relate to you, but they can't, because they're not in your shoes. In 'N Sync, there were four other people who were in the exact same position I was in, so they really did understand.

Clockwise from top left: A.J. McLean, Brian Littrell, Howie Dorough, Kevin Richardson and Nick Carter in the '90s.

BACKSTREET BOYS

● In 1997 five guys who came together in Florida and learned to dance as seamlessly as they harmonized unleashed a frothy pop sound and a spectacular show. With that, they reinvigorated the boy-band genre with the same energy as '80s superstars New Kids on the Block. Twelve hits and 35 million CD sales later, the five split—reuniting in 2005 for an album, *Never Gone*, and a tour. Brian Littrell, now 31, became a father and a Christian recording artist; Kevin Richardson, 33, had his Broadway debut in *Chicago*; A.J. McLean, 28, went into rehab and started a foundation to support diabetes research; Nick Carter, 26, dated Paris Hilton and signed for a reality show with his brother Aaron; Howie Dorough, 32, kept busy fund-raising for lupus (which claimed his sister). Might their next reappearance be as the Backstreet Men? No way, said Carter. "The Beach Boys never changed their name."

Winning a 1995 Grammy award was huge. "I remember Oprah coming up to us," says Salt (left, with Pepa and Spinderella in '94). "I was, like, Wow!"

"There are definitely plans" for a reunion, says Pepa (left, with Salt and Spinderella in '05).

HIP-HOP

By the '90s, rap music had come of age, old school gave way to G-funk. There was room for all: girls, gangstas and a white kid from Detroit

Salt-N-Pepa

With "Push It," "Let's Talk About Sex" and "Whatta Man," rap's first big female group was frank, feisty—and, of course, fun.

1 CHERYL JAMES
Salt, now 40 and a mother of two, switched to Christian music, recording her first solo album, *Salt Unrapped*, in 2005.

2 SANDRA DENTON
Pepa, 41, appeared on season 5 of *The Surreal Life* in 2005; after time out to raise her two kids, she's getting into acting.

3 DEIDRA ROPER
Deejay Spinderella, 35, is now a mom and still spins at parties, including several Hurricane Katrina charity events.

"We're vibing a lot of ska, reggae and old hip-hop," says Jean (left, with Hill and Pras in '05) of the Fugees' new sound.

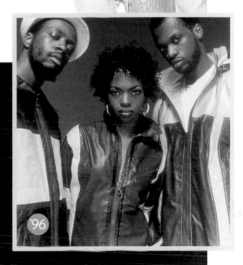
'96

THE FUGEES

● In 1996 they released their massively successful second album, *The Score*— and promptly split. "We had very strong opinions," says frontman Wyclef Jean of the breakup with Lauryn Hill and Pras. Hill emerged in 1998 with her stunning solo *The Miseducation of Lauryn Hill,* which was nominated for 10 Grammys; Pras has been acting and producing films; while Jean released five solo CDs and launched the Yéle Haiti foundation to benefit his homeland. But a 2004 reunion concert in Dave Chappelle's movie *Block Party*—their first in seven years—started something. Jean, now 36, Pras, 33, and Hill, 31—who has four kids with Rohan Marley (son of reggae legend Bob)—are back in the studio and did a 22-city European tour this year. "It was incredible," says Jean. "When you hit the stage, the screams remind you that damn, you are a rock star!"

Dr. Dre

● For some, inventing G-funk (a synthesizer-heavy style of rap) and thus putting his stamp on the evolution of music might have been enough. But the former member of N.W.A. (left, in '96) has gone on to wield even more power as a producer, record mogul (Death Row Records) and mentor to a string of distinctive hip-hop artists. *The Chronic*, with Dre supplying the beats and his discovery Snoop Dogg his inimitable timing and rhyming, became the gold standard of West Coast cool. Some five years later Dre took on a white rapper from Detroit with major attitude, producing *The Slim Shady LP* and *The Marshall Mathers LP* and making Eminem (right, in '99) a superstar. At 41, the married dad (born Andre Young) is also the man behind 50 Cent and platinum-selling West Coast rapper The Game. "I've hardly made any friends since I've been in this rap game," Dre has said. Like him or not, though, he has made plenty of stars.

:IN THE MIX

● Garth retired and hooked up with Trisha, Alanis (you oughta know) got engaged, the Boyz suffered health woes, and the Hooties celebrated parenthood. Party on, dudes

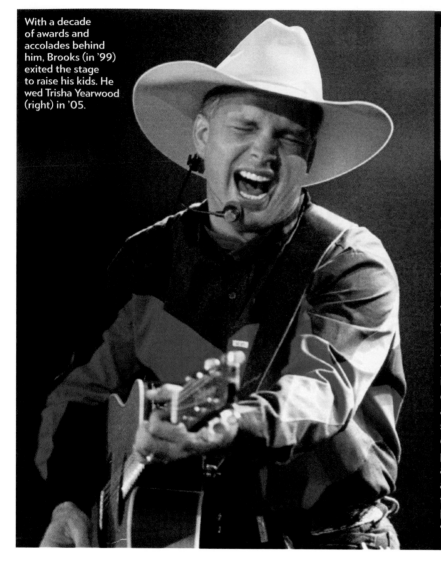

With a decade of awards and accolades behind him, Brooks (in '99) exited the stage to raise his kids. He wed Trisha Yearwood (right) in '05.

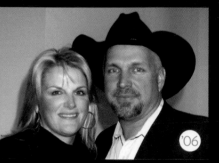

'06

GARTH BROOKS

● He was the King of Country in the '90s, but in 2000 Brooks expanded his realm by becoming the top recording solo artist of the decade in any genre. That same year he announced his retirement, filed for divorce from wife Sandy, with whom he has three daughters, and dated fellow country singer Trisha Yearwood (above), whom he wed in 2005. (He'd proposed before 7,000 fans at the unveiling of a bronze statue in his honor.) Now making his home on an Oklahoma ranch with Yearwood and the kids, Brooks, 44, may be considering a comeback. In 2006 he put out six previously unreleased tracks as part of a repackaged CD sold exclusively at Wal-Mart. And he made a rare appearance at a Texas benefit in '05. As the crowd sang along on "Unanswered Prayers," he wiped away tears and said, "I've missed this. Thank you."

'96

Alanis Morissette

● The Ottawa-born singer's 1995 international debut album, the auto-biographical *Jagged Little Pill,* sold more than 30 million copies world-wide and included the bitter bust-up song "You Oughta Know" (widely rumored to be about her ex-lover, *Full House* star Dave Coulier). That was then. At 32, Morissette is happily engaged to actor Ryan Reynolds, whom she began dating in '02. "At 14, I felt 30 in some ways," she says. "Now my emotions have caught up with my chronology. It feels good."

'06

From left: Mark Bryan, Darius Rucker, Dean Felber and Jim Sonefeld in '98.

Hootie & the Blowfish

● They were four likable college Joes, laid-back Southern rockers dismissed by some critics as "white-bread," yet their debut album, *Cracked Rear View*, ranks as one of the 15 bestsellers of all time. Today, the band—lead crooner Darius Rucker, 40, drummer Jim Sonefeld, 41, and bassist Dean Felber and guitarist Mark Bryan, both 39—play clubs as well as stadium shows and have their own label at Vanguard Records. "We all got married and had kids," says Rucker. "We got 11 between the four of us." Their music, he adds, is "about getting older. Ten years ago all we wanted to think about was drinking and women. Now there's a lot more to write about."

From left: Nathan Morris, Michael McCary, Wanya Morris and Shawn Stockman in '94.

BOYZ II MEN

● The first of the '90s boy bands and the most successful R&B group of all time, Boyz II Men has since struggled to regain its former success. A vocal-cord polyp plagued Wanya Morris, and scoliosis forced Michael McCary, 34, to retire in 2003. After a two-year hiatus, Wanya, 32, Nathan Morris, 35, and Shawn Stockman, 33, released *Throwback*, an album of cover songs, and last year the trio went on tour.

One-Hit Wonders

The soundtracks of entire summers, these tunes have become time capsules for the decade—while their creators are moving on

● LOU BEGA
"Mambo No. 5"
After his '99 ode to the ladies in his life, Bega, 31, toured "nonstop." His third studio album, *Lounatic*, is out this summer, to co-incide with the World Cup in Germany, now his home. The sound? "Up-tempo mood enhancers," he says.

● LOS DEL RIO
"The Macarena"
Antonio Romero (left) and Rafael Ruiz, 57, were stars in Spain before sparking that '96 dance craze in the U.S.—and still are, with 80 shows a year in their homeland. They still get asked for "Macarena." "We're not tired of it," says Romero.

● SISQO
"Thong Song"
His huge hit about tiny lingerie didn't prevent his second album from flopping here—but not in Europe. "In London they had a parade. I loved it," says the singer, 30, whose third solo album, *Last Dragon*, is out this summer.

● RIGHT SAID FRED
"I'm Too Sexy"
The Fairbrass brothers, Richard (right), 52, and Fred, 49, weren't hot enough to make their '92 fame last stateside, though with guitarist Rob Manzoli they perform regularly in Europe. The band released their latest album, *For Sale*, in January.

Who SANG IT?

Name that tune! Then match the lyrics to the artists who sang them

What if God was one of us? ❶
Just a slob like one of us
Just a stranger on the bus
Trying to make his way home

You can do side bends or sit-ups,
But please don't lose that butt ❷

I GET KNOCKED
DOWN
BUT I GET
UP AGAIN
YOU'RE NEVER
GOING TO KEEP
ME DOWN ❸

AND ALL THE ROADS WE HAVE TO WALK ALONG ARE WINDING
AND ALL THE LIGHTS THAT LEAD US THERE ARE BLINDING ❹

Ⓐ GREEN DAY

Ⓑ JOAN OSBORNE

Ⓒ TLC

Ⓓ BARENAKED LADIES

Ⓔ SIR MIX-A-LOT

Ⓕ LFO

And I'd give up forever to touch you
'Cause I know that you feel me somehow
You're the closest to heaven that I'll ever be
And I don't want to go home right now ⑤

MMMBOP,
BA DUBA DOP
BA DO BOP,
BA DUBA DOP
BA DO BOP,
BA DUBA DOP
DA DO.
OH YEAH ⑥

SO YOU GOT THE LOOKS, BUT
HAVE YOU GOT THE TOUCH?
DON'T GET ME
WRONG, YEAH, I THINK
YOU'RE ALRIGHT.
BUT THAT WON'T KEEP ME WARM
IN THE MIDDLE OF THE NIGHT ⑦

Fell deep in love but now we ain't speakin ⑧
Michael J. Fox was Alex P. Keaton
When I met you I said my name was Rich
You look like a girl from Abercrombie and Fitch

⑨

(And all that glitters is gold)
Only shooting stars break the mold

Chickity China the Chinese chicken
You have a drumstick and your
brain stops tickin'
Watchin' *X-Files* with no lights on,
we're dans la maison
I hope the smoking man's in this one
Like Harrison Ford I'm getting frantic
Like Sting I'm tantric ⑩

I don't want your number (no) ⑪
I don't wanna give you mine and (no)
I don't wanna meet you nowhere (no)
I don't want none of your time

IT'S SOMETHING ⑫
UNPREDICTABLE
BUT IN THE END IT'S RIGHT.
I HOPE YOU HAD
THE TIME OF YOUR LIFE

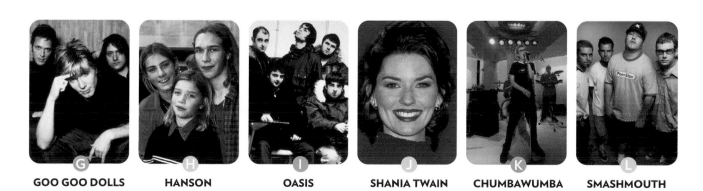

G GOO GOO DOLLS **H** HANSON **I** OASIS **J** SHANIA TWAIN **K** CHUMBAWUMBA **L** SMASHMOUTH

Answers: **1.** B: "One of Us."; **2.** E: "Baby's Got Back."; **3.** K: "Tubthumping."; **4.** I: "Wonderwall."; **5.** G: "Iris."; **6.** H: "MMMBop."; **7.** J: "That Don't Impress Me Much."; **8.** F: "Summer Girls."; **9.** L: "All Star."; **10.** D: "One Week."; **11.** C: "No Scrubs."; **12.** A: "Good Riddance (Time of Your Life)"

THE LATIN ELVIS
Ricky Martin

He stole the 1999 Grammys with his hip-shaking performance of "The Cup of Life" from his self-titled first English-language album. Later that year, "Livin' la Vida Loca" shot to No. 1 on the *Billboard* Hot 100. Despite the fame, Martin wasn't happy as man of the moment. "I want to go back in 10 years and feel that [this] is still as important to me," he said at the height of his success. Now 34, he recently toured with a new reggaeton cut, "Drop It on Me."

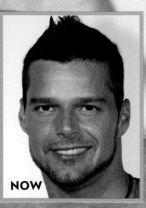

NOW

DO YOU THINK THEY'RE

Sexy?

From Ricky
Martin's Latin
swivel to Tyson
Beckford's
catwalk prowl,
these men were
on a mission to
drive us wild

*THE OBJECT
OF DESIRE*

Lucky
Vanous

In one of the decade's most
memorable TV commercials,
Vanous garnered instant
stardom playing a bare-
chested construction worker
with a thirst for Diet Coke. A
group of women in a nearby
office building—and loads
more watching on TV—
thought *he* was the tall drink.
Now 45, Vanous opened
a new American home-style
restaurant in L.A. in March.
Its name? Lucky Devils.

NOW

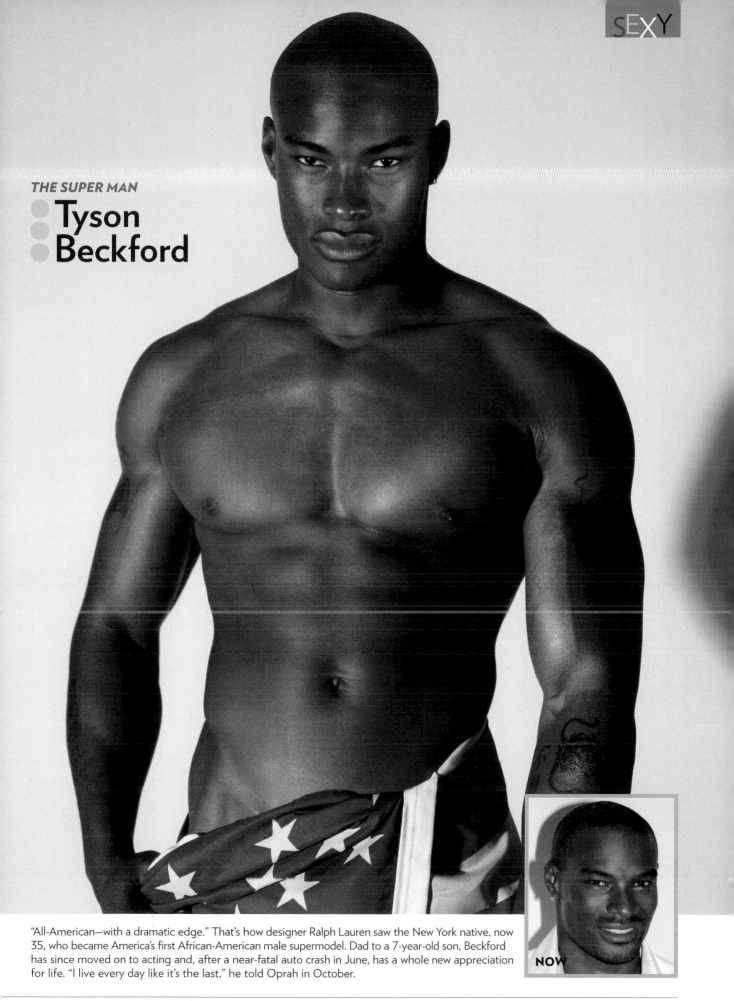

THE SUPER MAN

Tyson Beckford

NOW

"All-American—with a dramatic edge." That's how designer Ralph Lauren saw the New York native, now 35, who became America's first African-American male supermodel. Dad to a 7-year-old son, Beckford has since moved on to acting and, after a near-fatal auto crash in June, has a whole new appreciation for life. "I live every day like it's the last," he told Oprah in October.

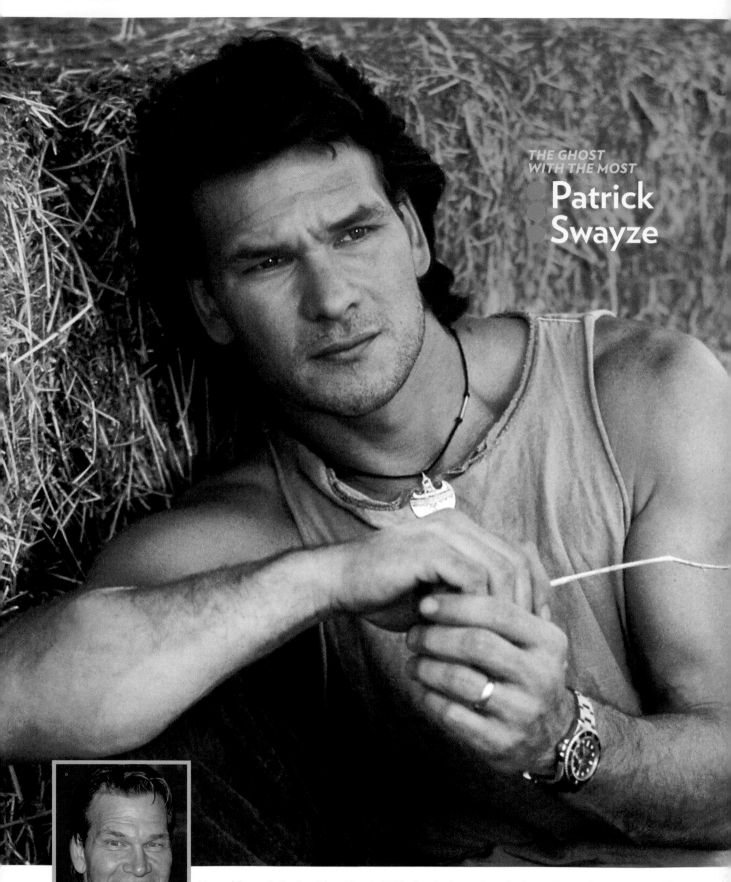

THE GHOST
WITH THE MOST
Patrick
Swayze

NOW

Named PEOPLE's Sexiest Man Alive in 1991 after he heated up the box office as Demi Moore's *Ghost* lover, the trained ballet dancer set himself apart from other heartthrobs by combining Texas cowboy machismo with a soft side. Married for 30 years to dancer Lisa Niemi, Swayze, 53, hopes to cut a rap single and is the voice of Cash in *The Fox and the Hound 2*.

Jean-Claude Van Damme

The buff Belgian who kick-boxed his way to fame in movies like *Double Impact* and *Timecop* saw his career falter after run-ins with his toughest opponent: cocaine. Now 45, Van Damme, who says he's "stronger than ever" after kicking the habit in 1998, is back to kicking butt in the DVD thriller *Second in Command*.

NOW

Fabio

Shooting to fame in the early '90s as the hard-bodied cover model for more than 1,000 romance novels, Fabio Lanzoni had fans lined up at his promotional appearances. They called his 900 number to hear him read steamy romances and bought his wall calendar. Back in the news in 1999 when a goose hit him in the face while he was riding a roller coaster, Fabio, now 47, just gave up his I Can't Believe It's Not Butter gig but is still the pitchman for Nationwide Insurance.

NOW

THE LORD OF THE PANTS

Michael Flatley

The fast-stepping, chest-baring *Lord of the Dance* star raked in $1 million a month in 1997 for his flashy take on traditional Irish footwork. And while critics weren't wowed by his tight leather pants—one dubbed the shows "schlock, sex and spectacle"—Flatley's adoring fans have kept him going strong. Now 47, he recently toured with his latest extravaganza, *Celtic Tiger*.

NOW

The headlines they made were shocking. But freeway fugitive O.J. Simpson now cruises in the slow lane, the Long Island Lolita is a housewife and mom, Monica Lewinsky's in grad school, and the McCaughey septuplets make mischief at age 8

NeWsM

Florence Ave 1/2
Manchester Blvd (42)
Century Blvd 1 1/2

AKErS

THE O.J. SIMPSON TRIAL

His controversial acquittal in the so-called "trial of the decade" still reverberates 10 years later

● **O.J. SIMPSON**

The Defendant

Though the jury in a 1997 civil suit found Simpson liable for killing wife Nicole and her friend Ron Goldman, his $300,000 from annual pensions, including the NFL, is exempt from the $33.5 million awarded in damages. Acquitted of battery in a 2001 road-rage incident, O.J., 58, has since kept a low profile, skiing, golfing and dating sometime girlfriend Christie Prody.

" If it doesn't fit, you must acquit"
—defense attorney Johnnie Cochran (1937-2005)

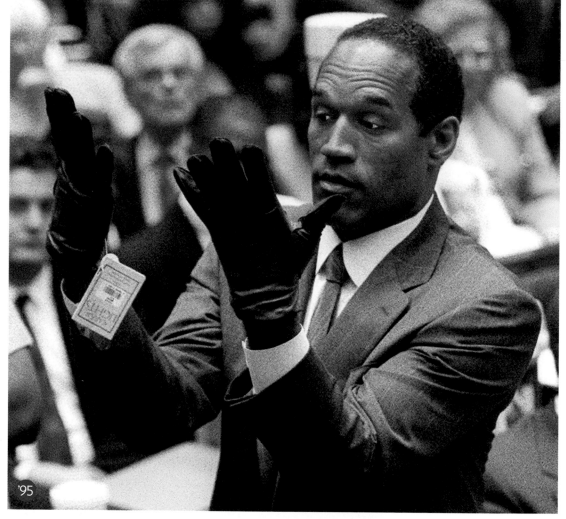

'95

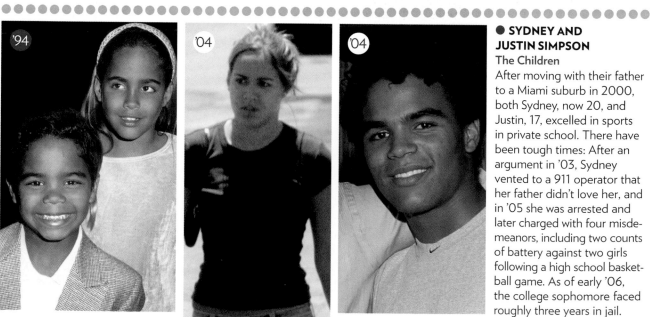

'94

'04

'04

● **SYDNEY AND JUSTIN SIMPSON**

The Children

After moving with their father to a Miami suburb in 2000, both Sydney, now 20, and Justin, 17, excelled in sports in private school. There have been tough times: After an argument in '03, Sydney vented to a 911 operator that her father didn't love her, and in '05 she was arrested and later charged with four misdemeanors, including two counts of battery against two girls following a high school basketball game. As of early '06, the college sophomore faced roughly three years in jail.

What I'd Do Differently
by Christopher Darden, Co-Lead Prosecutor

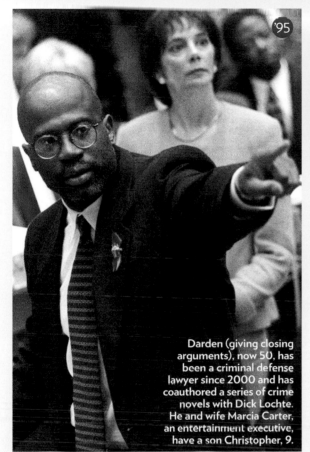

'95

Darden (giving closing arguments), now 50, has been a criminal defense lawyer since 2000 and has coauthored a series of crime novels with Dick Lochte. He and wife Marcia Carter, an entertainment executive, have a son Christopher, 9.

'04

People still ask "Do you think O.J.'s guilty?" I reply, "Why the hell would I prosecute him if he wasn't?" Having said that, there are some things I would have done differently. For starters, I would absolutely not do the glove demonstration again. The media spin on that was horrific, and in a high-profile case, spin is crucial. Letting the jurors tour Simpson's home was boneheaded and added nothing to our case. Overall, the case should have been streamlined. It's hard to convince a jury that a man killed two people in two minutes when it takes the coroner five days to tell how he did it. But the Simpson case was unique too. It came two years after the Los Angeles riots, three years after the Rodney King beating. A lot of black folks are suspicious of the LAPD, and the defense used that suspicion to its advantage. I was on *Oprah* recently, and she says she believes Simpson did it—but the fact is, a lot of public people in the black community have never said that. Why hasn't Jesse Jackson said something? I know it's been 10 years, but it's not too late. They ought to speak up, because obviously the verdict had a polarizing effect, and my community is still polarized by race. As for Simpson himself, I pretty much ignore him. Now, if he made a public confession or committed another murder, I'd pay attention to that. But beyond that, I don't pay much attention to which blonde he's dating.

'06

● KATO KAELIN
The Witness
The world's best-known houseguest moved out of the bungalow on O.J.'s Brentwood estate and into his own L.A. condo. Embarking on a lecture tour about his post-trial fame (called, aptly, "The 16th Minute"), Kaelin, 47, scored bit parts in B-movies, then went to work in '03 in the comedy development division of National Lampoon. A single father of one, he has likened himself to Norm on *Cheers*. When he walks into a bar, "it's like, 'Hey, Kato! What's going on?'"

'04

● MARK FUHRMAN
The Cop
His perjured testimony about using a racial epithet ended his career as an LAPD detective. But Fuhrman, 54, rebounded as a radio talk show host, cable news analyst and bestselling author.

'05

● MARCIA CLARK
Co-Lead Prosecutor
The deputy D.A. may have lost the case, but she gained a $4.2 million advance for her 1997 memoir *Without a Doubt*. Clark, 52, went on to work as a legal commentator for *Entertainment Tonight* and the E! channel.

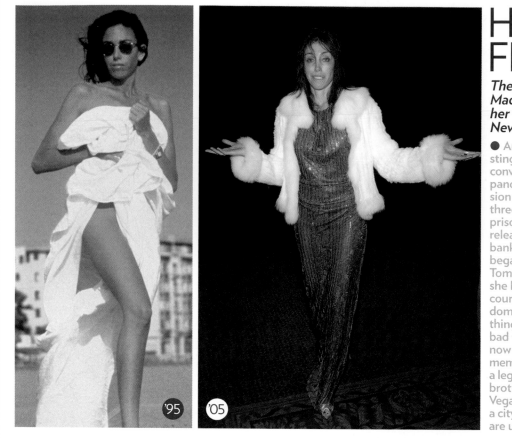

HEIDI FLEISS

The Hollywood Madam takes her business to Nevada

● Arrested in a '93 sting, Heidi Fleiss was convicted of attempted pandering and tax evasion in '95 and served three years in federal prison. Upon her release, Fleiss filed for bankruptcy and soon began dating actor Tom Sizemore, whom she later brought to court on 16 counts of domestic violence. But things haven't been all bad for Madam Fleiss, now 40. She wrote her memoir and is planning a legally regulated male brothel outside Las Vegas. "It's like building a city," she says. "These are uncharted waters."

'95 '05

Larry Fortensky

Seven years after a fall that put him in a monthlong coma, Liz Taylor's ex is still recovering from his injuries

'90 '02

● Elizabeth Taylor's seventh ex-husband has had his ups and downs since their 1996 divorce. The pair, who met in 1988 at the Betty Ford Center, married in '91 at Michael Jackson's Neverland Ranch but were KO'd five years later by "irreconcilable differences." Fortensky had a near-fatal accident in '99 when he fell down a flight of stairs and sustained severe head injuries. "I'm still recovering," says the former construction worker, 54, who lives with his sister in Temeculah, Calif., and still calls Taylor once a month. "I lost my short-term memory, but I'm doing fine."

John and Patsy Ramsey

Feeling under siege, the family headed east to escape the cloud of suspicion over JonBenét's murder

'97

'04

● When 6-year-old beauty queen JonBenét Ramsey was found dead in her Boulder, Colo., basement the day after Christmas in 1996, John and Patsy Ramsey were the prime suspects. Though they came under fire for their parenting, they were never charged with her murder and have always denied any involvement in the still unsolved crime. Now living in Atlanta, John, 62, ran unsuccessfully for a House seat in Michigan (the couple have a home there) in '04. Observed Patsy, 49, who is battling ovarian cancer: "For better or worse, we have really tested the vows."

McCaughey Septuplets

Active at 8, the busy Iowa second graders keep their family on their toes

● They made history when they entered the world on Nov. 19, 1997, 9½ weeks premature. Now, the world's only living set of septuplets—Brandon, Natalie, Joel, Alexis, Nathan, Kelsey and Kenny McCaughey—are typical 8-year-olds, albeit separated in seven different classrooms at Carlisle Elementary School in Carlisle, Iowa. Mom Bobbi, 37, and dad Kenny, 36, juggle everyday needs—which don't include shoes; Kmart has promised the children free footwear through age 10—with the physical demands of Alexis and Nathan, who have cerebral palsy. Bobbi homeschools older daughter Mikayla, 10 ("This will get my mom's attention for me again," Mikayla said), and works two days a week at the same powder-coating factory where Kenny has a full-time assembly-line position. Are they raising seven little angels? "When they're all in the same place, the group mentality kicks in," Bobbi said. "They're conniving together and get into more mischief. If it's just one, they're the best-behaved kids on the planet."

'05

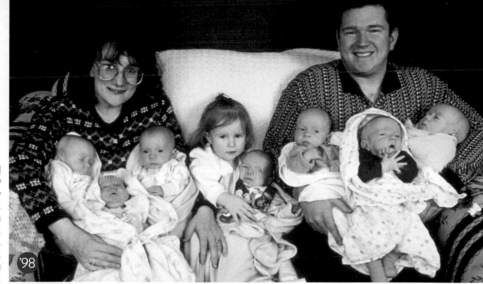

Then, Bobbi and Kenny McCaughey and their instantly expanded family. Now (below, from left): Brandon, Natalie, Joel, Alexis, Nathan, Kelsey, Kenny Jr. and big sister Mikayla.

'98

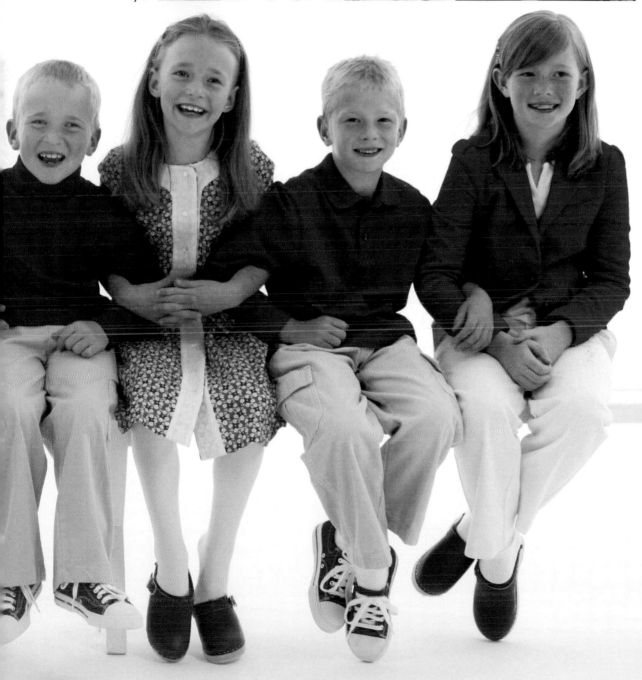

Jesse Ventura

After a contentious term as governor, the pro wrestler takes a step back from politics

'99

'05

● Jesse "The Body" became Jesse "The Mind" when he won the '98 Minnesota governor's race (on the Reform Party ticket) with just 37 percent of the vote. Four years, one controversial *Playboy* interview (he called organized religion "a sham") and many press feuds later, Ventura, now 55, announced he wouldn't seek reelection. Since leaving office in '03, he's been a spokesman for the Costa Rica-based gambling Web site BetUs.com and has recently been in talks to star in an NBC sitcom. "I could never be a career politician," he says. "I believe in telling the truth."

ROSS PEROT

He made the biggest third-party splash since Teddy Roosevelt

Quirky Texas billionaire Ross Perot bankrolled a populist third-party presidential campaign in '92 that pulled 18.9 percent of the popular vote—possibly the factor that unseated George H.W. Bush and elected Bill Clinton. A second run in '96 was a relative bomb, and the ex-IBM salesman, now 76, dropped out of the limelight and concentrated on his IT business.

" The people are good, but they have a government that is a mess" '92

'05

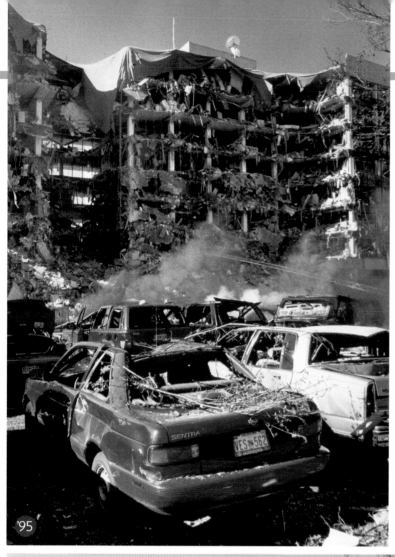

'95

OKLAHOMA CITY BOMBING

Eleven years later, the children who were rescued are living normal lives, despite some lingering injuries

● When a Ryder truck filled with ammonium nitrate fertilizer exploded outside the Alfred P. Murrah Federal Building on April 19, 1995, 19 of the 168 killed were children from the second-floor daycare center. But six survived. Christopher Nguyen had severe burns and a broken jaw. Now 15, he likes to cook but says, "My mother doesn't want me to set the house on fire." Joe Webber, 19 months, was buried by the blast. A healthy preteen today, he says he might like to be a pilot. Only 50 feet from the explosion, Rebecca Denny, 2, recovered quickly, but brother Brandon, 3, was struck in the head and had the upper-left portion of his brain removed. Both are in middle school, but Brandon has to take special physical education classes. Nekia McCloud, now 15, spent five weeks in a coma after the blast and "had to learn everything over again," says her mother, LaVerne. Four months shy of his second birthday, P.J. Allen sustained severe burns to his lungs, had a tracheal tube until '04 and still has breathing problems. The 12-year-old wants to be an engineer. "I'd like to build things," he says.

From left: P.J. Allen, Brandon Denny, Christopher Nguyen, Nekia McCloud, Rebecca Denny and Joe Webber visit the "Survivor Tree" at the Oklahoma City National Memorial.

'05

MONICAGATE

Washington's most famous intern and the woman who recorded her confessions traded politics for private life

'96

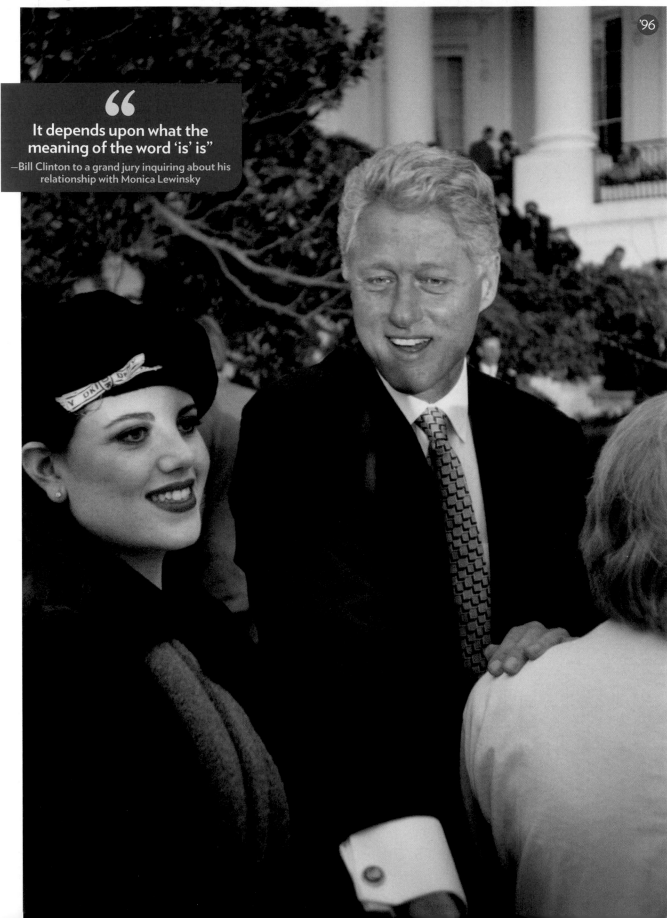

> **"**
> **It depends upon what the meaning of the word 'is' is"**
> —Bill Clinton to a grand jury inquiring about his relationship with Monica Lewinsky

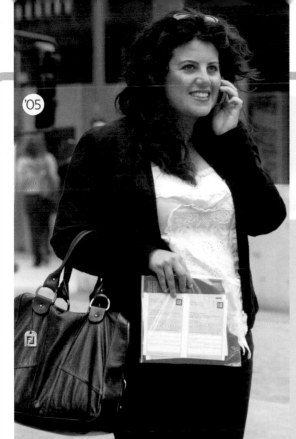

'05

● **MONICA LEWINSKY** Goes Back to School

After a tell-all book and a stint as a handbag designer, Lewinsky, 32, is working on her master's in social psychology at the London School of Economics. Classmates say she keeps to herself. But then, Lewinsky insists she isn't there for publicity, "I hope to make a meaningful and significant contribution to the field," she told a New York City newspaper in '05.

MONICA'S HANDBAGS
She designed some, then bagged it
When Lewinsky launched her handbag line in 2000, the cloth totes sold for $100-$200 at stores like Manhattan's Henri Bendel. The "Real Monica" handbags can now be found on eBay starting at 99¢.

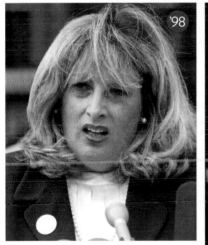

'98

'03

● **LINDA TRIPP** Runs a Boutique

Shedding the image of a snitch wasn't easy for Linda Tripp. After undergoing a series of makeovers, she fled the Maryland home that "became a tourist trap" and in 2001 lost her Pentagon job. "People either think I'm a hero or a villain," she says. "I'm neither." Now 56 and a breast cancer survivor, Tripp runs the Christmas Sleigh holiday boutique in Middleburg, Va., with husband Dieter Rausch, a childhood friend whom she married in 2004, and lives part-time in Rausch's native Germany. Still, says Tripp, "you can never get your anonymity back."

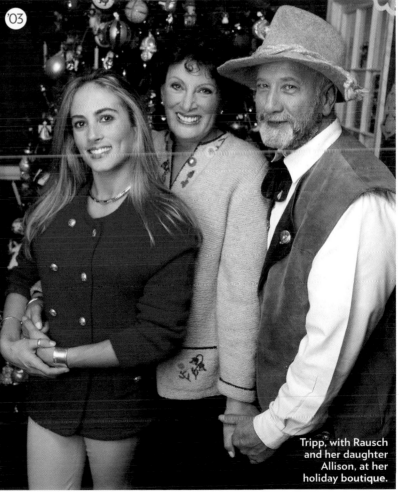

Tripp, with Rausch and her daughter Allison, at her holiday boutique.

AMY FISHER AND JOEY BUTTAFUOCO

*The "Long Island Lolita"
and her paramour did time
and started over*

● The sensational '93 trial left
Joey Buttafuoco with a six-
month statutory-rape sentence
and his lover Amy Fisher behind
bars for seven years for shooting
his wife, Mary Jo, in the face.
Released in '99 after Mary Jo
asked the judge for leniency,
Fisher, 31, is now a mother of
two with husband Lou Bellera,
55. The Buttafuocos divorced in
'03 and Joey, now 50, moved on
to reality TV. He crossed paths
with Amy at the Lingerie Bowl in
February, and producers are
shopping a TV interview of the
trio to networks.

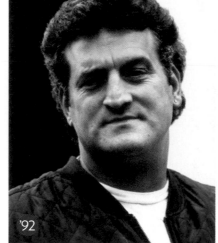

'92

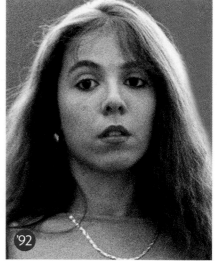

'92

Buttafuoco and Fisher
turned up in February at
the Lingerie Bowl to toss
the coin to determine
which team would get first
possession of the pigskin.

'06

Erik and Lyle Menendez

Convicted of their parents' murders, the brothers forged new lives in prison

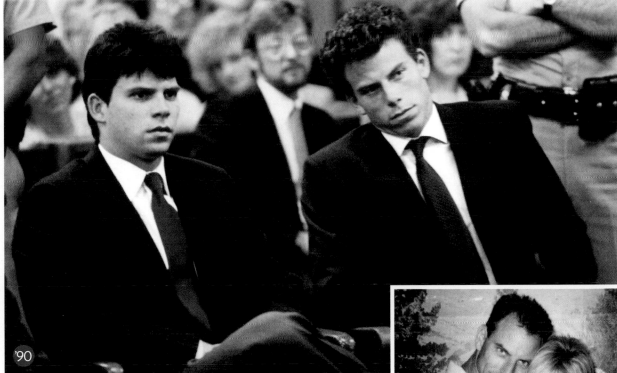

'90

● Sentenced in '96 to life in prison without the possibility of parole for their parents' 1989 murders, Erik and Lyle Menendez have not been allowed contact, though they may communicate via letters. Lyle, 38, who married Rebecca Sneed in '03, now works as a clerk in his lone, Calif., prison. Erik, 35, married pen pal Tammi Saccoman in '99 at his Coalinga, Calif., prison. (She wrote a book about making marriage work when one spouse is doing time.) "I wanted to carve a life for myself in prison," says Erik. "I'm trapped in a moment, forever a murderer, but I believe I am a good person."

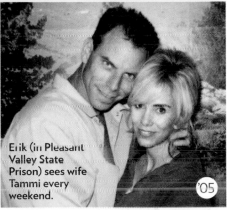

Erik (in Pleasant Valley State Prison) sees wife Tammi every weekend.

'05

William Kennedy Smith

Acquitted of rape, he went on to become a doctor

● Since his acquittal after a televised 1991 trial, William Kennedy Smith, 45, has kept a low profile. Known to introduce himself simply as "Will Smith," the Chicago rehabilitation medicine specialist had another brush with the law in '04, when a former assistant sued him for "emotional distress" following an alleged sexual assault. A judge dismissed the suit.

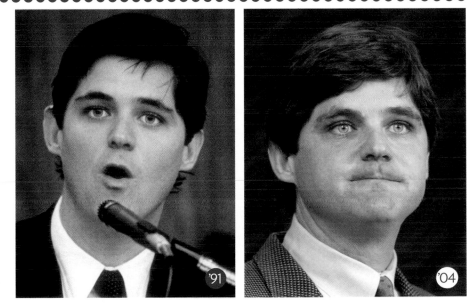

'91

'04

Who SAID IT?

Match the notables with the words they made quotable

I DIDN'T INHALE. ❶

I'm much more than a pair of breasts. I represent success, hard work and fun. ❷

I do not like broccoli. And I haven't liked it since I was a little kid and my mother made me eat it. And I'm President of the United States and I'm not going to eat any more broccoli. ❸

A
GEORGE H.W. BUSH

B
MICHAEL JACKSON

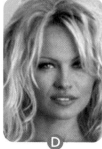
C
BILL GATES

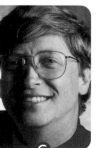
D
PAMELA ANDERSON

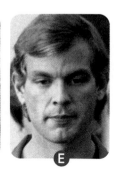
E
JEFFREY DAHMER

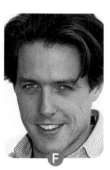
F
HUGH GRANT

I think you know in life what's a good thing to do and what's a bad thing, and I did a bad thing. **4**

ME AND JANET REALLY ARE TWO DIFFERENT PEOPLE. **5**

Someday, kids will spend more time on a PC connected to the Internet than in front of the TV. It will be a much richer experience. **6**

Rule 1: Be a creature unlike any other. **7**

CAN WE ALL GET ALONG? **8**

Yep, I'm gay. **9**

There were three of us in this marriage, so it was a bit crowded. **10**

YOU'RE CLOSE, BUT YOU LEFT A LITTLE SOMETHING OFF. THE 'E' ON THE END. **11**

They tasted like beef. **12**

G
ELLEN DeGENERES

H
RODNEY KING

I
ELLEN FEIN SHERRIE SCHNEIDER

J
DAN QUAYLE

K
PRINCESS DIANA

L
BILL CLINTON

Answers: 1. L, 2. D, 3. A, 4. F, 5. B, 6. C, 7. I, 8. H, 9. G, 10. K, 11. J, 12. E

THE WAY WE READ

From a farmhouse romance to a neurotic Londoner's diary, Oprah's favorite recipes to the revelation that yes, men are from Mars, these bestsellers chronicled the decade

STOP THE INSANITY!
Susan Powter

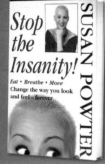

● **HOW BIG WAS IT?** This gospel of fitness combined with female empowerment, based on Powter's route to her own 133-lb. weight loss, moved some 3 million copies and gave birth to an empire of ear-splitting videos. "What a great message," says Powter, now 48. "It was directed at people who say they don't have a spare hour to exercise, and at starvation diets that never work."

● **CATCHING UP** Her trademark platinum buzz cut has given way to braids, but Powter's feistiness has remained intact through six more books, a divorce and the 1997 birth of a son (her third). "To this day, I'm out living my life and women come up to me and say, 'Stop the insanity!' " says Powter, who lives in Seattle and sells videos (her latest: *Trailer Park Yoga*) on her wellness Web site, susanpowteronline.com. "People still recognize me."

THE CELESTINE PROPHECY
James Redfield

● **HOW BIG WAS IT?** Before there was *The Da Vinci Code* there was *The Celestine Prophecy*, a new-age adventure novel about the pursuit of an ancient Peruvian manuscript which contains nine key spiritual insights. Originally self-published, *Celestine* became a runaway hit on word-of-mouth publicity, ultimately selling upward of 14 million copies.
● **CATCHING UP** Now at work on the fourth book in the *Celestine* series, Redfield, 56, also cowrote the script for this year's movie adaptation. "I wanted to keep the movie true to the book," he says. "It's a philosophical description of the spiritual awakening we're seeing around the world."

MEN ARE FROM MARS, WOMEN ARE FROM VENUS
John Gray, Ph.D.

● **HOW BIG WAS IT?** Analyzing how men and women view relationships differently, the self-help tome sold 14 million copies.

● **CATCHING UP** Following up with titles like *Mars and Venus in the Bedroom* and *The Mars & Venus Diet & Exercise Solution,* Gray, 54, has stuck with his formula. "The big theme is that men and women cope differently," he says. "I always tie it in."

IN THE KITCHEN WITH ROSIE: OPRAH'S FAVORITE RECIPES
Rosie Daley

● **HOW BIG WAS IT?** With 50 of "Oprah's favorite recipes," from Sweet Potato Pie to "Un-fried" Fried Chicken, the low-fat cookbook from O's personal chef sold more than 6 million copies.

● **CATCHING UP** Cowriting *The Healthy Kitchen* with Dr. Andrew Weil, Daley, 44, expands her healthy-eating crusade with more exotic fare, like Miso Pâté.

SIMPLE ABUNDANCE: A DAYBOOK OF COMFORT AND JOY
Sarah Ban Breathnach

● **HOW BIG WAS IT?** Ban Breathnach's essays aiming to help women pare down their lives and find joy in everyday things sold more than 7 million copies.

● **CATCHING UP** After a hiatus in which Ban Breathnach divorced, moved to England and remarried, the author hopes to share her lessons learned with her latest book, *Moving On,* which teaches women how to reorder their lives. "It's the practical application of simple abundance," says Ban Breathnach, now 59. "What do all those unpacked boxes that we haul from home to home mean, and if we haven't moved on from the past, how can we create our own house of belonging?"

BRIDGET JONES'S DIARY
Helen Fielding

● **HOW BIG WAS IT?** The laugh-out-loud journal of a slightly pudgy, hopelessly neurotic thirty-something singleton sold more than 10 million copies and helped give chick lit a hilarious start.

● **CATCHING UP** Fielding, 48, has brought Bridget back to life—now with a baby—in Britain's *Independent* newspaper, where the column originated. "It might just make it into a book," says Fielding, "depending on how the baby behaves." Living in L.A. with boyfriend Kevin Curran, a writer for *The Simpsons,* and their 2-year-old son Dashiell, she is also "toying with a couple of screenplay ideas." But is she happy? "If I could just lose another 7 lbs. . . . ," she says.

THE BRIDGES OF MADISON COUNTY
Robert James Waller

● **HOW BIG WAS IT?** Waller's three-hanky tale of middle-aged passion in 1960s Iowa topped the bestseller list for a record 162 weeks. A '95 movie version starred Clint Eastwood and Meryl Streep.

● **CATCHING UP** Waller, now 66 and living in rural west Texas, released his third installment of the *Bridges* trilogy, *High Plains Tango,* in '05.

IN SEVENTH HEAVEN AGAIN

Gymnastics

The 1996 U.S. Olympic gymnastics team became known as "The Magnificent Seven" after winning America's first team gold medal in the sport. That victory, says Dominique Dawes, "helped our sport immensely, not only because we won, but because of our diversity. We were a rainbow. We touched a great deal of people."

'96

Dominique Dawes

Dawes, 29, graduated from the University of Maryland with a communications degree. President of the Women's Sports Foundation, she's now a motivational speaker.

Dominique Moceanu

Engaged to a medical resident, Moceanu, 24, is a gymnastics instructor in Cleveland when she's not attending classes at nearby John Carroll University.

Kerri Strug

After the Games, "my parents said, 'We're so happy you accomplished your dream, but now you're going to school.'" Strug, 28, who earned a master's in psychology at Stanford, now works for the Justice Department.

Amy Chow

For kicks, Chow, 28 and a medical student at Stanford, has taken up another sport: pole vaulting. She has cleared 12'11½" in practice and competed in local meets.

From the balance beam to the basketball court, the skating rink to the soccer field, these memorable athletes gave it their all and gave fans something to cheer about

Jaycie Phelps

Phelps, 26, teaches gymnastics in Colorado Springs, where she lives with new husband Brett McClure, a 2004 silver medalist in gymnastics. Phelps had hoped to make the team in 2000, but an injury prevented a repeat appearance.

Amanda Borden

In 2004, Borden, 29, opened her own gymnastics academy in Tempe, Ariz., where she settled after graduating from Arizona State. She also teaches algebra to middle schoolers.

Shannon Miller

Miller, 29, has been attending law school at Boston College but is not out of gymnastics: "I teach balance beam to kids and coaches, and I'm involved with summer camps."

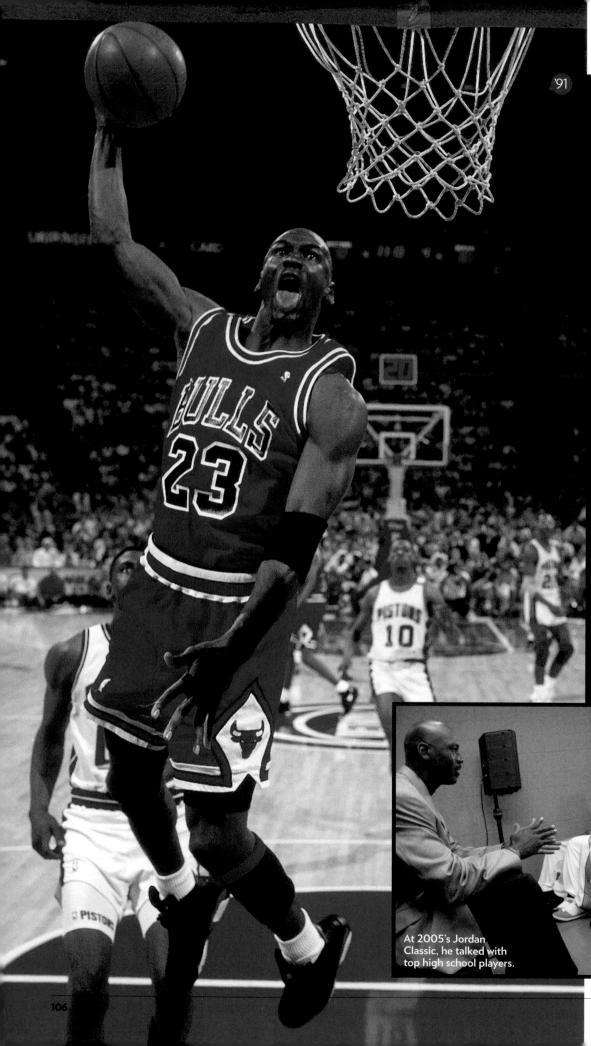

'91

MICHAEL JORDAN

Basketball

● He hasn't played since 2003, but Jordan, 43, is still the world's best-known athlete. It's not just the six NBA titles he won with the Chicago Bulls—three coming after he "retired" to play professional baseball (not all that well, as it turned out). Or his endorsement deals or his starring role in 1996's *Space Jam*. It's because he's never off our radar—he plays often in high-profile golf and poker tournaments, and he invested in team motorcycle racing, his new favorite sport. As for his old one, he's thinking about buying an NBA team. "I have the capital," he told the *Chicago Tribune*, "but if I'm going to pay $375 million, can I make money and can it sustain itself? Once I see a situation where it can, I'll jump."

At 2005's Jordan Classic, he talked with top high school players.

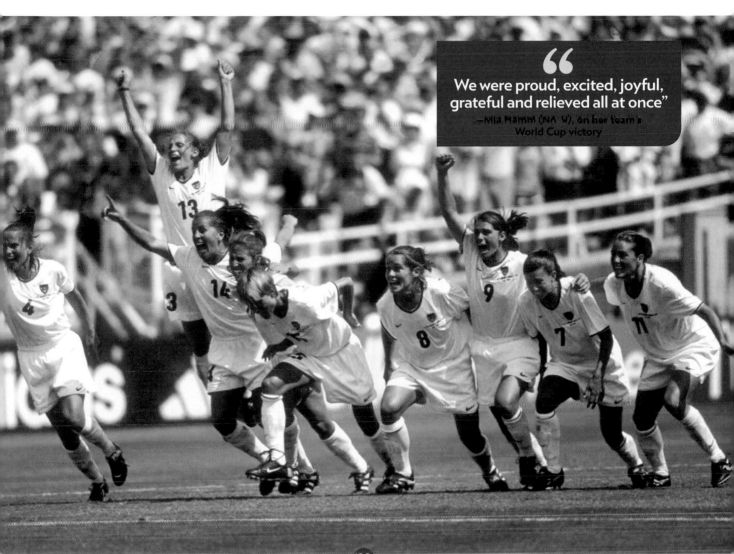

> **"We were proud, excited, joyful, grateful and relieved all at once"**
> —Mia Hamm (NA 'Y), on her team's World Cup victory

U.S. Women's World Cup Team

Soccer

● "When we started," says recently retired U.S. team captain Julie Foudy, 35, "we were just a team who loved to play. There wasn't even money involved." With little fanfare, the women won their first World Cup in 1991. Five years later, they took the gold medal at the Atlanta Olympics. By 1999, when the team won its second World Cup, this time in front of a packed Rose Bowl, women's soccer had become the sport to watch. Today, three of the team's stars—Foudy, Brandi Chastain, 37, and Mia Hamm, 34—are involved in promoting girls' sports programs, and they're still close. "We've experienced the highest highs and lowest lows together," says Hamm of her teammates. "I hope to keep in touch with them for years to come."

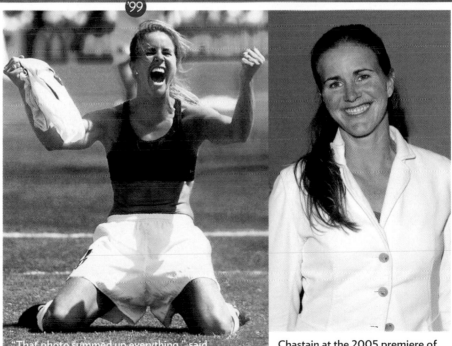

'99

"That photo summed up everything," said Chastain. "That it was okay to be yourself. I'm glad I did it with gusto."

Chastain at the 2005 premiere of HBO's *Dare to Dream: The Story of the U.S. Women's Soccer Team.*

Yamaguchi (holding Emma in '05) with Bret and Keara.

KRISTI YAMAGUCHI

Figure Skating

● In 1992, she became the first U.S. woman to win an Olympic gold medal in figure skating since 1976. Now 34 and the mother of two daughters (with husband Bret Hedican, a defenseman for the NHL's Carolina Hurricanes), she says, "After the Olympics I turned pro and really stayed out there. I was active in competitions, shows, tours and skating on TV." She's still skating. "Even kids born after 1992 recognize me," she says. "I'm always surprised."

'92

John Elway
Football

● Following back-to-back Super Bowl wins in 1998 and 1999, the Denver Broncos' star quarterback retired after 16 seasons with the team. But as co-owner of the Arena Football League's Colorado Crush, the 46-year-old divorced father of four hasn't left the game. "It's kind of my little baby," he says of the Crush, the 2005 league champions. "I put it together from scratch, and I enjoy it because it gets me as close to playing as I can."

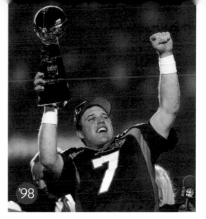
'98

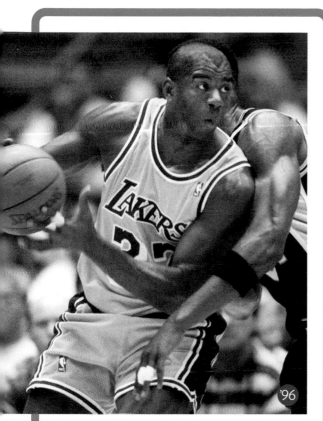
'96

MAGIC JOHNSON **Basketball**

● One of his sport's legends—five NBA championships with the Los Angeles Lakers, 12 All-Star team selections—Johnson got even more attention with his shocking 1991 announcement that he had contracted HIV. Today, the still-strapping father of three owns shopping plazas, movie theaters, restaurants and a recording company. Now 46 and symptom-free, he also promotes HIV/AIDS awareness.

'95

Monica Seles
Tennis

● By 1993, the Yugoslavian-born Seles had won eight Grand Slam titles. But her career was derailed by an insane fan who knifed her in the back during a match in Germany. After a '95 comeback, she now raises money for children's tennis programs. As for playing again? "It's not an easy decision," said Seles, 32, "because if you do come back, you want to come back at a high level."

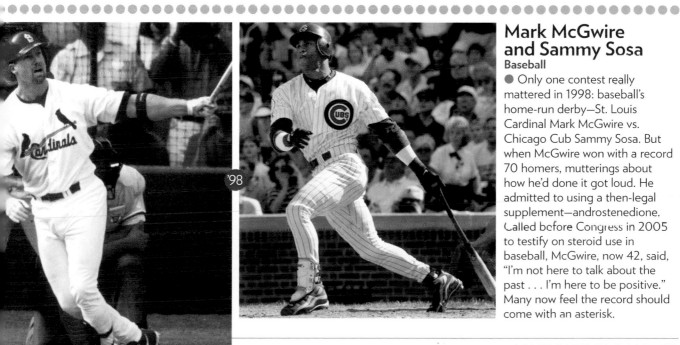
'98

Mark McGwire and Sammy Sosa
Baseball

● Only one contest really mattered in 1998: baseball's home-run derby—St. Louis Cardinal Mark McGwire vs. Chicago Cub Sammy Sosa. But when McGwire won with a record 70 homers, mutterings about how he'd done it got loud. He admitted to using a then-legal supplement—androstenedione. Called before Congress in 2005 to testify on steroid use in baseball, McGwire, now 42, said, "I'm not here to talk about the past . . . I'm here to be positive." Many now feel the record should come with an asterisk.

George Clooney
THEN He had small parts in seven series—including a stint as Det. James Falconer in *Sisters* (below)—before his breakthrough role on *ER*. **NOW** A 2006 Oscar nominee for director and screenplay, Clooney won for Best Supporting Actor in *Syriana*.

'93

Bit-part players blossomed into big-screen icons. Child stars became Ivy Leaguers and now have kids of their own. Still other actors (like a fella named Clooney) have blazed whole new careers. Who could have predicted?

THINGS HAVE

ChA

nGEd

:JACKPOT

In the '90s you might not have given these stars a second glance. In hindsight, of course, each seems to have possessed that special spark—an attitude, an aura, a look—that marked them for greatness later on

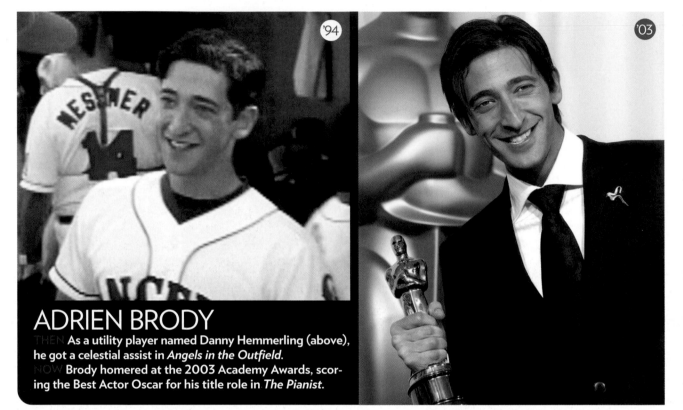

'94

'03

ADRIEN BRODY
THEN As a utility player named Danny Hemmerling (above), he got a celestial assist in *Angels in the Outfield*.
NOW Brody homered at the 2003 Academy Awards, scoring the Best Actor Oscar for his title role in *The Pianist*.

'05

'98

Scarlett Johansson
THEN She played a troubled teen tamed by Robert Redford in *The Horse Whisperer*.
NOW Johansson (left, at the premiere of *The Island*) got a 2006 Golden Globe nod for *Match Point*.

JENNIFER LOPEZ

THEN J.Lo (below) danced as a Fly Girl on FOX's *In Living Color*.
NOW No longer just "Jenny from the Block," the Bronx-born singer-actress is a corporation unto herself, with clothing and fragrance lines.

Hilary Swank

THEN The onetime *90210* regular connected with Ian Ziering (far right).
NOW Swank hoisted the second of her two Best Actress Oscars (for *Million Dollar Baby*) at the *Vanity Fair* party in 2005.

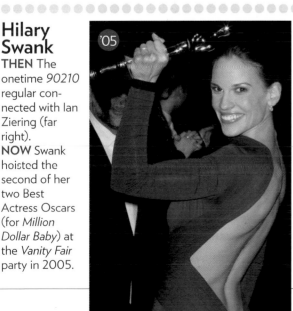

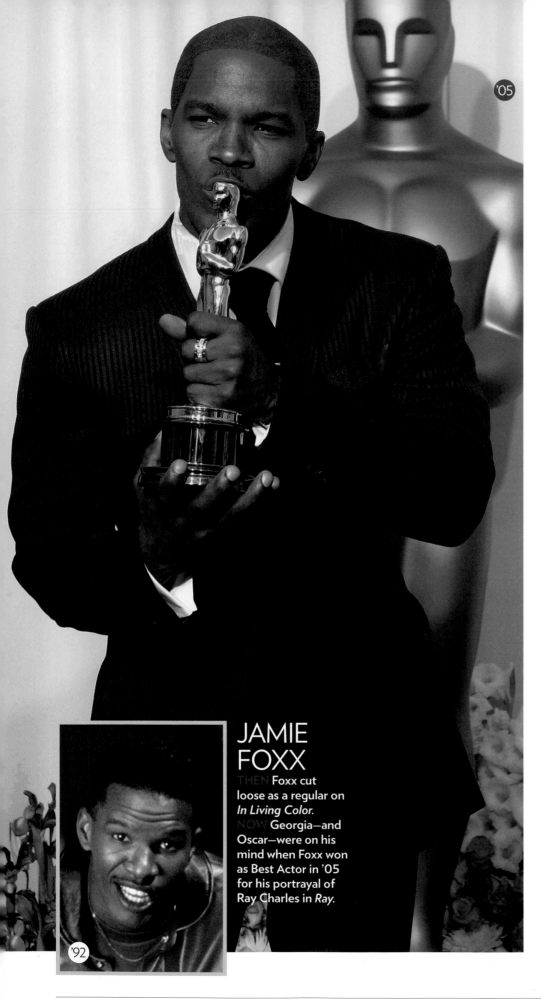

'05

'95

Renée Zellweger

THEN She was a music-store employee (above) in *Empire Records*.
NOW Previously twice-nominated (for *Bridget Jones's Diary* and *Chicago*), Zellweger took home the 2004 Best Supporting Actress Oscar for *Cold Mountain*.

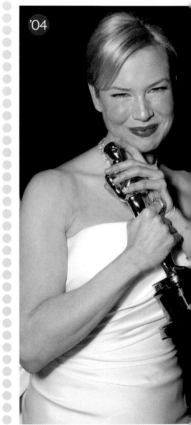

'04

JAMIE FOXX

THEN **Foxx cut loose as a regular on** *In Living Color.* NOW **Georgia—and Oscar—were on his mind when Foxx won as Best Actor in '05 for his portrayal of Ray Charles in** *Ray.*

'92

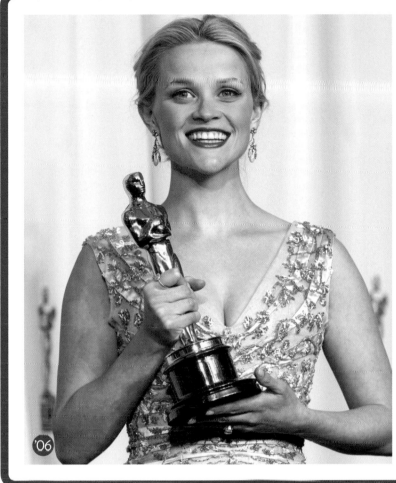

'06

'91

REESE WITHERSPOON

THEN She broke out as a rural teenager in love in *The Man in the Moon* (below), then graduated to *Pleasantville* and *Election* by decade's end.
NOW The *Legally Blonde* bombshell copped the 2006 Best Actress Oscar as June Carter Cash in *Walk the Line*.

'91

'06

Jake Gyllenhaal

THEN He was Billy Crystal's son (above) in *City Slickers* and played a real-life rocket scientist in 1999's *October Sky*.
NOW Critics lauded Gyllenhaal in 2005's *Brokeback Mountain*, which brought him a Best Supporting Actor Oscar nomination.

:ALL GROWN UP

Remember when Mary-Kate and Ashley played Michelle? Macaulay was left *Home Alone*? Lindsay was caught in *The Parent Trap*? What a difference a decade makes!

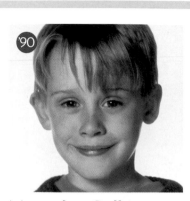

'90

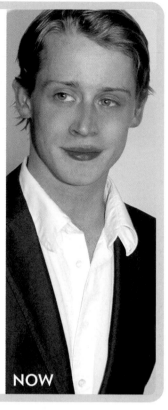

NOW

Macaulay Culkin

● A star at age 10 in *Home Alone* and an emancipated minor at 16 after clashing with his father over his finances, he was a husband at 17 and single again at 19. Culkin's led a full life, and that's not even counting his friendship with Michael Jackson. Now 25 and dating actress Mila Kunis, he's written a semiautobiographical novel, *Junior.* "I don't know where I fit in," he said.

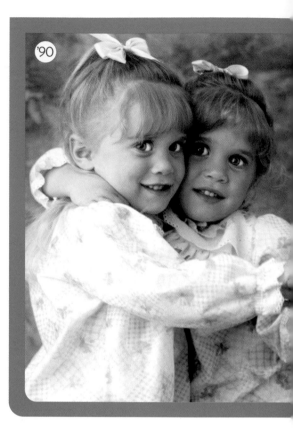

'90

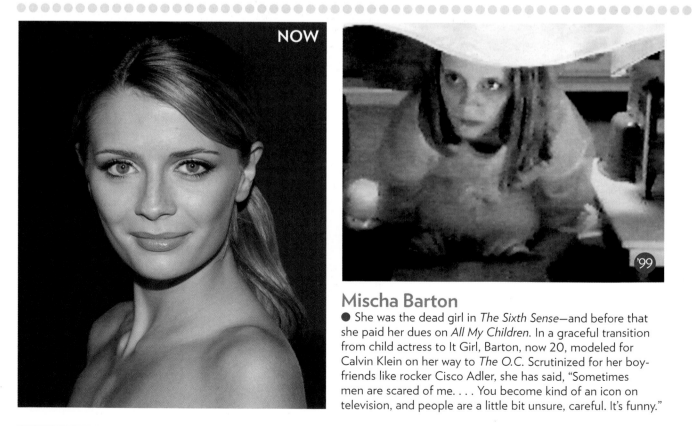

NOW

'99

Mischa Barton

● She was the dead girl in *The Sixth Sense*—and before that she paid her dues on *All My Children*. In a graceful transition from child actress to It Girl, Barton, now 20, modeled for Calvin Klein on her way to *The O.C.* Scrutinized for her boy-friends like rocker Cisco Adler, she has said, "Sometimes men are scared of me. . . . You become kind of an icon on television, and people are a little bit unsure, careful. It's funny."

THE OLSEN TWINS

● When *Full House* ended in 1995, the fraternal twins, who shared the role of Michelle Tanner, were just 9. Now 20, the multimillionaire businesswomen have gone their separate ways: Mary-Kate (right), who battled an eating disorder, recently filmed a part in *Factory Girl* with Sienna Miller; Ashley attends New York University. They appear together in ads for Badgley Mischka.

Lindsay Lohan

● With her Disney-perfect freckles, the 11-year-old Lohan was born to star in the family-friendly *The Parent Trap*. After films like *Freaky Friday*, though, she was ready for a change. She released two pop albums and landed more mature roles in movies like *Chapter 27*, the story of John Lennon's killer. But bad press about her nightclub antics and run-ins with the paparazzi threatened her image. Not that, at 20, she has regrets. "All my decisions are things that I make," she told *Vanity Fair* in '06, later adding that she hopes to write a film about "how crazy a person can go. But, at the same time, how much they can change."

NOW

'98

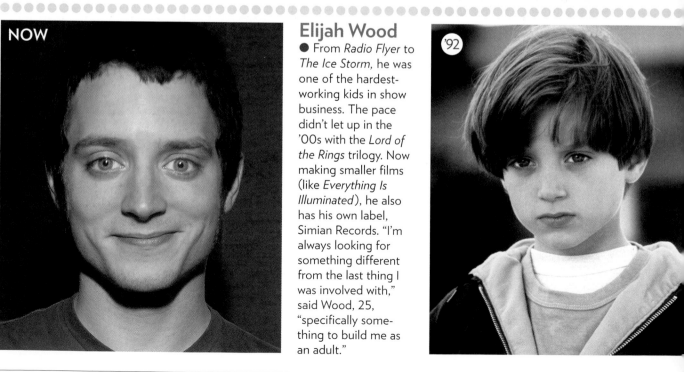

NOW

Elijah Wood

● From *Radio Flyer* to *The Ice Storm*, he was one of the hardest-working kids in show business. The pace didn't let up in the '00s with the *Lord of the Rings* trilogy. Now making smaller films (like *Everything Is Illuminated*), he also has his own label, Simian Records. "I'm always looking for something different from the last thing I was involved with," said Wood, 25, "specifically something to build me as an adult."

'92

'95

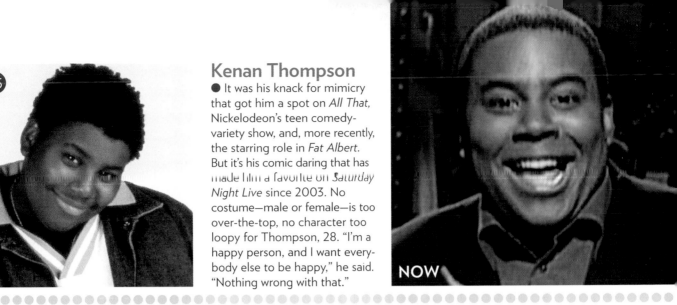

Kenan Thompson

● It was his knack for mimicry that got him a spot on *All That,* Nickelodeon's teen comedy-variety show, and, more recently, the starring role in *Fat Albert.* But it's his comic daring that has made him a favorite on *Saturday Night Live* since 2003. No costume—male or female—is too over-the-top, no character too loopy for Thompson, 28. "I'm a happy person, and I want everybody else to be happy," he said. "Nothing wrong with that."

NOW

'94

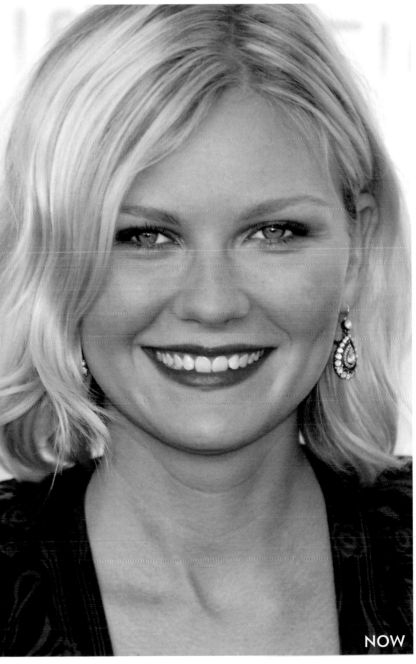

KIRSTEN DUNST

● After meeting a wicked end as *Interview with the Vampire*'s child of the night, she had a new beginning as an A-list star. Now filming her third installment of *Spider-Man,* Dunst, 24, is as famous for her big-name dates (her relationship with Jake Gyllenhaal ended in 2004) as she is for her big-budget movies. The veteran of more than 30 films has said, "People always tell me, 'Don't work so much,' but I can't help it. I feel like all the things I've done are important to get to this adult stage, and now I'm getting all these adult offers, so it's working."

NOW

'99

NOW

HALEY JOEL OSMENT

● Seeing dead people in 1999's *The Sixth Sense* made him one of the youngest actors nominated for an Oscar. Listening to his mom and dad kept him grounded. "My parents have done a really good job at keeping it normal," said Osment, 18. While he has continued to work intermittently in films, his latest project is choosing a college. He's leaning Ivy League.

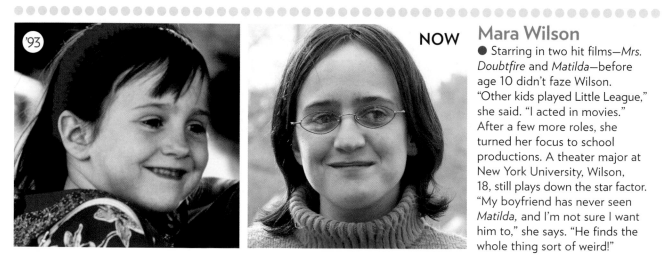

'93

NOW

Mara Wilson

● Starring in two hit films—*Mrs. Doubtfire* and *Matilda*—before age 10 didn't faze Wilson. "Other kids played Little League," she said. "I acted in movies." After a few more roles, she turned her focus to school productions. A theater major at New York University, Wilson, 18, still plays down the star factor. "My boyfriend has never seen *Matilda,* and I'm not sure I want him to," she says. "He finds the whole thing sort of weird!"

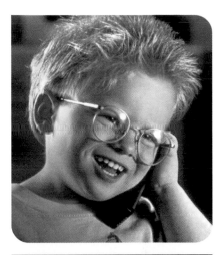

Jonathan Lipnicki

● He had us at "The human head weighs 8 lbs." The 5-year-old who melted Tom Cruise's heart as little man Ray Boyd in *Jerry Maguire* went on to appear in two *Stuart Little* films and in TV guest spots. Now 15 and attending high school in California, he has played drums in a band and kickboxes. "People think the cute kid from *Jerry Maguire* can't kick butt," he said. "But I'm pretty good."

NOW

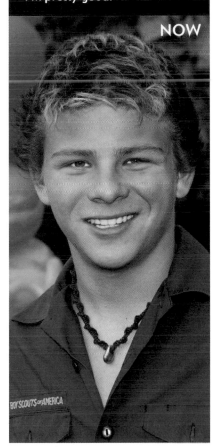

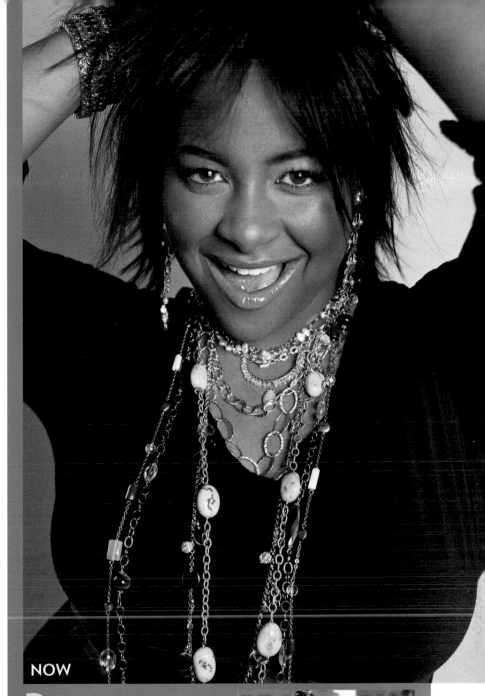

NOW

Raven-Symoné

● Just 3 when she first appeared on *The Cosby Show*, she has fond, if dim, memories of her time as the Huxtables' grandchild. "I remember the smell of Mr. Cosby's cigars and soul food," she said. Dozens of TV and film roles and three pop CDs later, Symoné, 20, has built a mini-empire with her series *That's So Raven*, spinning off clothes, perfume, bedding, books and dolls. "I like to have fun," she said, "but this is a critical time for me and my career, so I stay focused."

'90

:A LEAGUE OF THEIR OWN

For these young stars of the '90s, it was all about the Ivies—even if they didn't get the degree

 HARVARD.

● **SCOTT WEINGER**
Full House, 1993
Weinger studied English and French at Harvard, where he graduated magna cum laude in '98.

● **NATALIE PORTMAN**
The Professional, 1994
The Harvard grad says her '03 psychology degree made her feel "less like a chess piece."

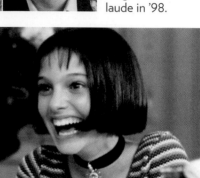

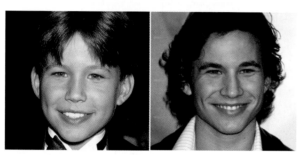

● **JONATHAN TAYLOR THOMAS**
Home Improvement, 1993
JTT headed to Harvard in '01 to study history and philosophy.

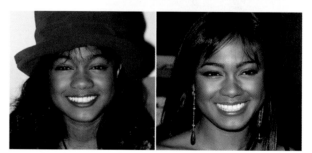

● **TATYANA ALI**
The Fresh Prince of Bel-Air, 1992
"I wanted to try new things," Ali says of her '02 degree in government from Harvard.

COLUMBIA UNIVERSITY.

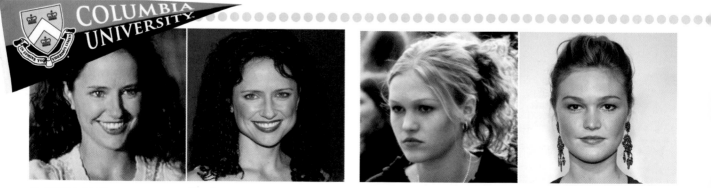

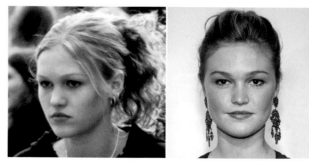

● **JEAN LOUISA KELLY** *Mr. Holland's Opus,* 1995
Wanting to "be a regular student," Kelly took four years off to major in English at Columbia.

● **JULIA STILES** *10 Things I Hate About You,* 1999
She took time off for films, but Stiles left Columbia with a degree in English in '05.

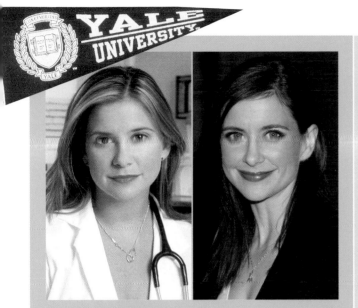

● **KELLIE MARTIN** *ER*, 1998
The *ER* actress left the top-rated show in '00 to finish her art history degree at Yale.

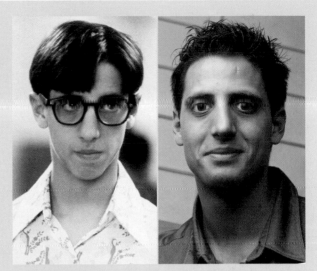

● **JOSH SAVIANO** *The Wonder Years*, 1990
The nerdy sidekick graduated from Yale in '98 with a political science degree. He's now a corporate lawyer.

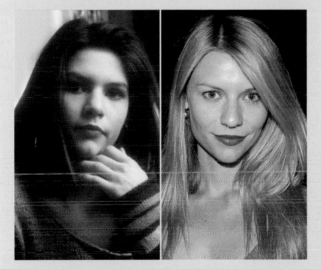

● **CLAIRE DANES** *My So-Called Life*, 1994
After two years at Yale, the *Shopgirl* star put her psychology studies on hold.

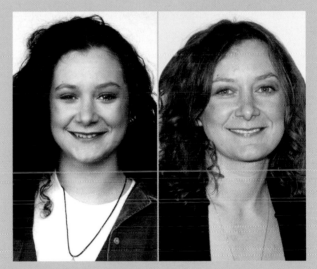

● **SARA GILBERT** *Roseanne*, 1991
The *Roseanne* star studied art and photography at Yale and graduated with honors in '97.

● **ANNA PAQUIN** *The Piano*, 1994
The *X-Men* star enrolled at Columbia in '00 but has been on leave since freshman year.

BROWN

● **LEELEE SOBIESKI**
Never Been Kissed, 1999
She started her Japanese lit studies at Brown in '01 but left without a degree.

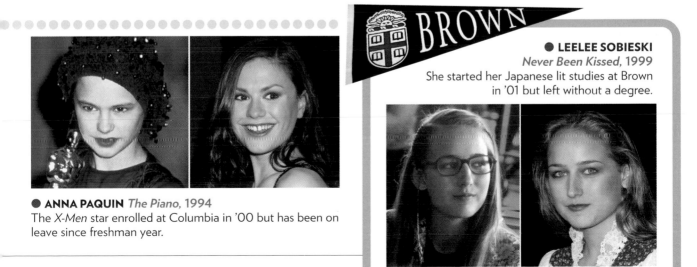

THEY WERE KIDS;
NOW THEY'RE PARENTS

You knew them as vivacious—and precocious—TV teens called D.J., Clarissa, Moesha and Britney. Today they all answer to the same name: Mom

NOW
MOTHER
OF MASON
WALTER

1996
*CLARISSA
EXPLAINS IT ALL*

Melissa Joan Hart
● The former star of *Clarissa Explains It All* and *Sabrina the Teenage Witch*, 30, and her husband, rocker Mark Wilkerson, welcomed their first child, Mason Walter, in early 2006. Dad even wrote him a lullaby. "He seems to like it," says his mom. "But he also likes any kind of noise."

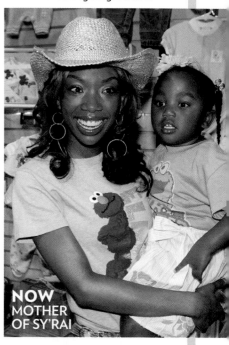

BRANDY
● The R&B Grammy winner and former *Moesha* star gave birth four years ago to a daughter, Sy'rai (suh-RYE), by her ex, music producer Robert Smith. After ending her engagement to New York Knicks basketball star Quentin Richardson in 2005, Brandy remains a doting single mom.

NOW
MOTHER
OF SY'RAI

1996
MOESHA

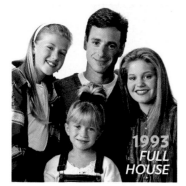

1993
*FULL
HOUSE*

Candace Cameron
● She was D.J. on *Full House,* and most of her TV family (above, with Cameron at right) attended her '96 wedding, at 20, to Russian-born NHL star Valerí Bure (boo-RAY). At 30, Cameron (right, with husband and brood in '05) is a full-time mom to daughter Natasha, 7, and sons Lev, 6, and Maxim, 4.

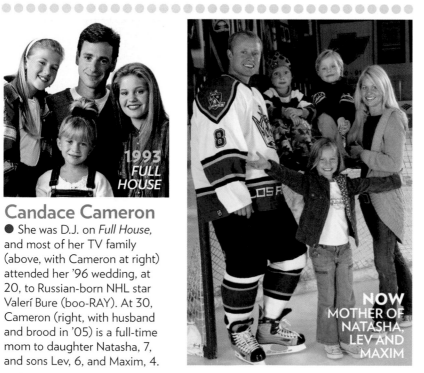

NOW
MOTHER OF
NATASHA,
LEV AND
MAXIM

NOW
MOTHER OF
SEAN PRESTON

1993
*THE MICKEY
MOUSE CLUB*

BRITNEY SPEARS

● The future pop diva was just 11 when she broke out as a regular (along with Justin Timberlake and Christina Aguilera) on the early-'90s reincarnation of *The Mickey Mouse Club* (above). International fame soon followed, after her 1999 debut album, . . . *Baby One More Time*, and four follow-up discs sold more than 60 million units worldwide. Even though she hasn't released a studio album in two years, on the personal side life hasn't slowed down. After a much-publicized relationship with Timberlake, she married backup dancer Kevin Federline in 2004. A year later she produced Sean Preston (left). Now Spears is getting ready for baby one more time. In May, she announced on *Late Show with David Letterman* that she's pregnant with her second little Federline.

Meet More 'Rents

Hand out cigars to these former teen movie, TV and pop stars, all of them experiencing the joys of parenthood

● **MARK-PAUL GOSSELAAR,** 32
'89–'94:
Zack on *Saved by the Bell*
NOW: Father of Michael, 2, and Ava, 2 months

● **BRADLEY PIERCE,** 23
1995:
The brother in *Jumanji*
NOW: Father of Gavin, 9 months

● **MAYIM BIALIK,** 30
'91–'95:
Teen star of *Blossom*
NOW: Mother to a son born in October 2005

● **TAYLOR HANSON,** 23
'97–PRESENT:
Middle brother in Hanson
NOW: Dad to Jordan, 3, and Penelope, 1

● **MICHAEL FISHMAN,** 24
'88–'97: D.J. on the sitcom *Roseanne*
NOW: Father of two: Aaron and Jamie

:FAMILY TIES

From the Mowry sisters to the Wayans brothers, these real-life showbiz siblings stuck together onscreen and off

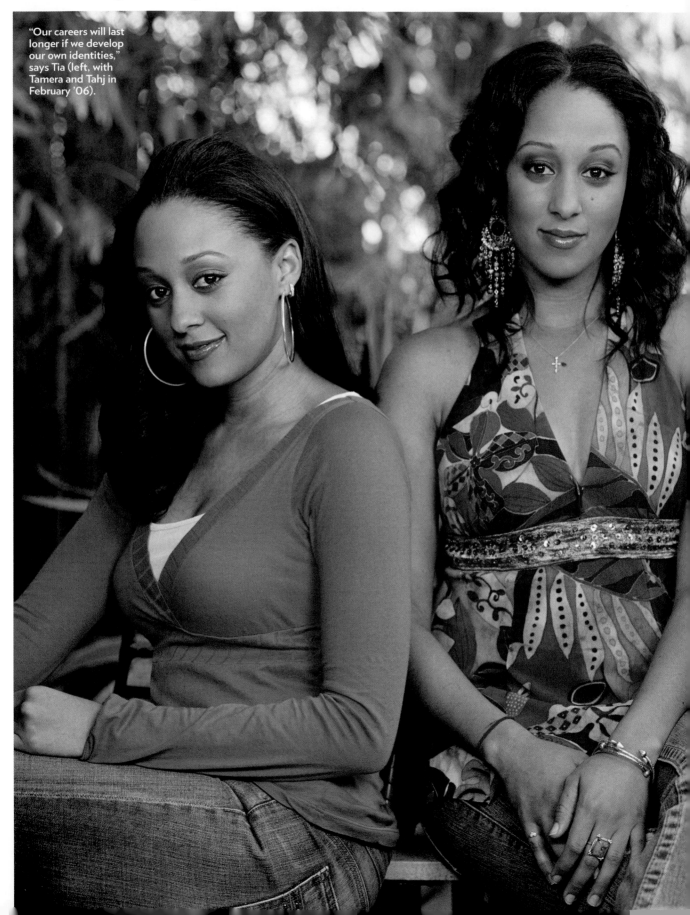

"Our careers will last longer if we develop our own identities," says Tia (left, with Tamera and Tahj in February '06).

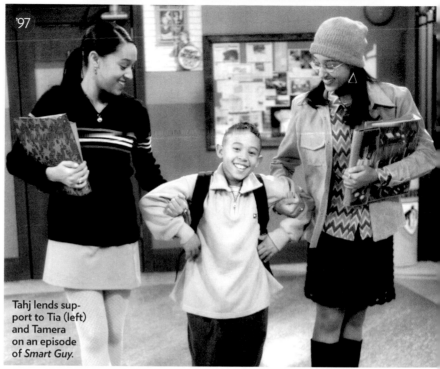

'97

Tahj lends support to Tia (left) and Tamera on an episode of *Smart Guy*.

● **MOWRY FAMILY**

They played twins on *Sister, Sister* for six seasons and both got psychology degrees at Pepperdine. Now 28, Tia and Tamera Mowry still spend plenty of time together. Their acting projects are separate, but "every Saturday is sister day," says Tamera, who's seeing FOX News reporter Adam Housley. (Tia dates actor Cory Hardrict.) "We get our nails done, take our dogs to the park." Kid brother Tahj, 20, who had his own sitcom, *Smart Guy*, is an advertising major at—where else?—Pepperdine, and doing voice work for the animated series *Kim Possible*. "We're all friends," he says. "They come to me for advice about their boyfriends."

● **LONDON TWINS**

Between Jason London's memorable turn as a quarterback in the '93 cult hit *Dazed and Confused* and twin brother Jeremy's stint as Neve Campbell's love interest on *Party of Five,* the London brothers had the heartthrob market cornered. Now 33, they're still acting but say the transition hasn't been easy. "I'm too young to play the dad and too old to play the son," explains Jason (he has a 9-year-old daughter, Cooper). They're financing a film written and directed by Jason, starring Jeremy. "It's funny," says Jason. "We've always had a you-scratch-my-back-and-I'll-scratch-yours career."

"We look alike," says Jason (left), "but our personalities are different."

'96

Jeremy at an '05 benefit.

Jason at an '05 party.

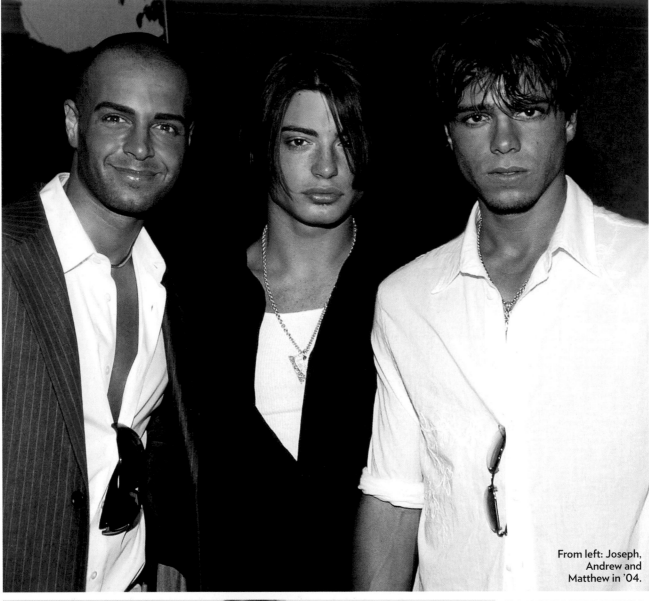

From left: Joseph, Andrew and Matthew in '04.

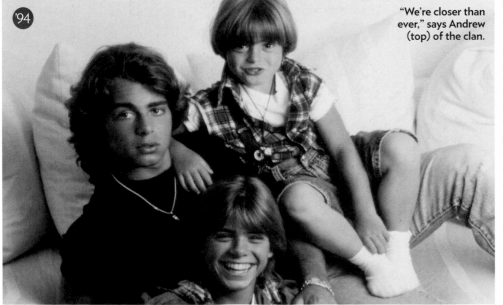

'94

"We're closer than ever," says Andrew (top) of the clan.

● **LAWRENCE BROTHERS**
Joseph is the best known after playing Joey Russo on *Blossom*, but the three sibs starred in the 1995-97 sitcom *Brotherly Love*. Now wed to second wife Chandie, Joseph, 30, "has taken on the father role," says Andrew, 18, who in turn talks to Matthew "almost every day. As a joke, we send each other husband-and-wife birthday cards!" Matt, 26, says, "We all want good roles. I don't want to play the jock anymore." The three are developing a reality show for VH1 that will follow Andrew seeking a recording contract.

● WAYANS BROTHERS

Sixteen years after the debut of *In Living Color,* the Wayans brothers are still collaborating. Keenen Ivory Wayans, 48, directed his brothers Shawn, 35, and Marlon, 33, in the *Scary Movie* series and *White Chicks.* Damon Wayans, 45, made his directorial debut with 2004's *Behind the Smile,* featuring Marlon, and starred in the ABC comedy *My Wife and Kids,* sometimes written by his sister Kim, 44. "The great thing is we all do the same thing," says Marlon. "You have to respect each other's opinions because we're all in the same business."

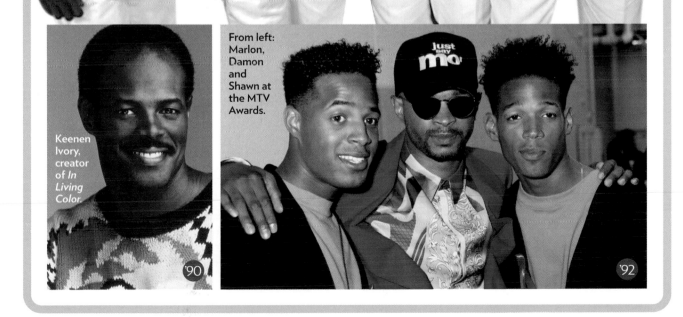

Keenen Ivory, creator of *In Living Color.*

'90

From left: Marlon, Damon and Shawn at the MTV Awards.

'92

:THEY MARRIED WHO?

When these couples hooked up, the world said . . . huh? Turns out the world was right

● MARIAH CAREY & TOMMY MOTTOLA
June 5, 1993 He was head of her record label, Sony; she was a Grammy winner 20 years his junior. They split four years later (he's now married to Mexican singer Thalia).

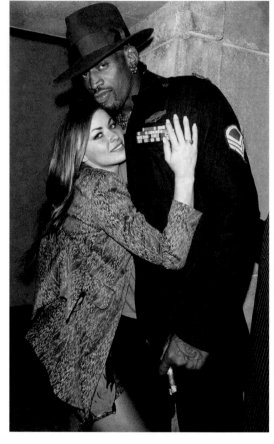

● CARMEN ELECTRA & DENNIS RODMAN
November 14, 1998 The *Baywatch* star and the bizarre b-baller wed after a night of partying in Vegas. Afterward, "we all went back to the Hard Rock for breakfast," she said. It lasted nine days.

● RICHARD GERE & CINDY CRAWFORD
December 12, 1991 The supermodel gave the movie star an ultimatum: Marry me or I walk. "I didn't want to lose her," said Gere of their Vegas nuptials—but he did, three years later. He's now married to actress Carey Lowell; Crawford to entrepreneur Rande Gerber.

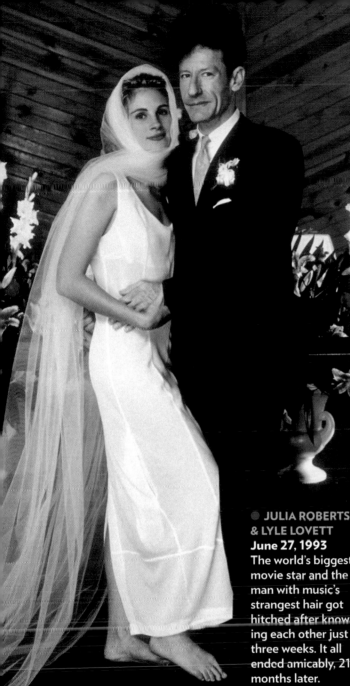

● **JULIA ROBERTS & LYLE LOVETT**
June 27, 1993
The world's biggest movie star and the man with music's strangest hair got hitched after knowing each other just three weeks. It all ended amicably, 21 months later.

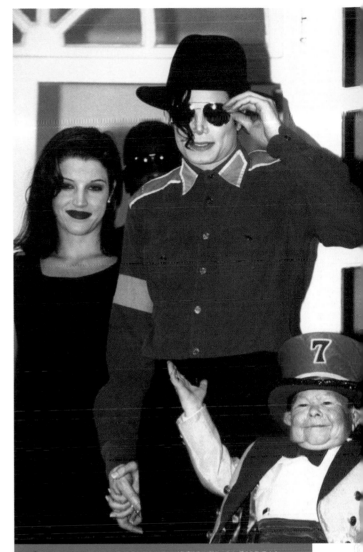

● LISA MARIE PRESLEY & MICHAEL JACKSON
May 26, 1994 After the King of Pop secretly wed Elvis's daughter in the Dominican Republic, the pair hung in Hungary with Michu the circus midget. The era's oddest couple split not long after.

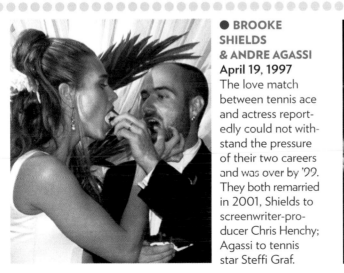

● **BROOKE SHIELDS & ANDRE AGASSI**
April 19, 1997
The love match between tennis ace and actress reportedly could not withstand the pressure of their two careers and was over by '99. They both remarried in 2001, Shields to screenwriter-producer Chris Henchy; Agassi to tennis star Steffi Graf.

● **PAULA ABDUL & EMILIO ESTEVEZ**
April 29, 1992
Her musical star was ascendant; his acting career was on the way down when Estevez proposed on bended knee. Abdul was interested in another tradition—having children—but Estevez, already the father of two, declined. They divorced in 1994.

⦂ SHIFTING GEARS

Is there life after acting? Just ask Governor Schwarzenegger. Or other stars who have made the leap to new careers. Like the *Growing Pains* kid who's now a chef. The *90210* hunk turned paramedic. And the *Night Court* jester making magic in New Orleans

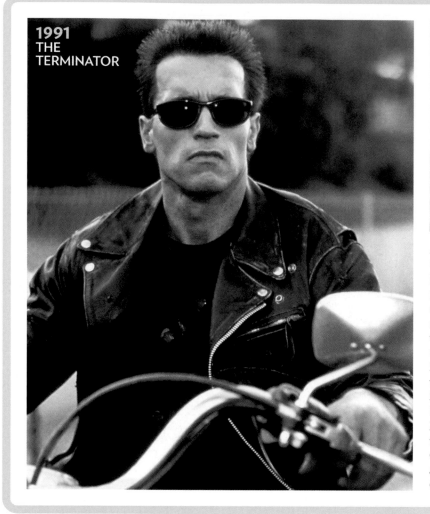

1991
THE
TERMINATOR

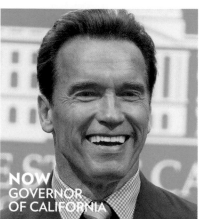

NOW
GOVERNOR
OF CALIFORNIA

Arnold Schwarzenegger

In the '90s the onetime body-building champ turned action hero played androids, clones, commandos, even a pregnant man, but Ah-nuld scored his unlikeliest role in 2003, when the star of three *Terminator* movies was elected "governator." Since then, Schwarzenegger, 58 and wed since '86 to NBC journalist Maria Shriver, has seen his popularity slip. But he plans to run for reelection in 2006. "We cannot start some-thing and not finish it," he told ABC's George Stephanopoulos. "I will walk away from this when we have rebuilt California." In short: He'll be back.

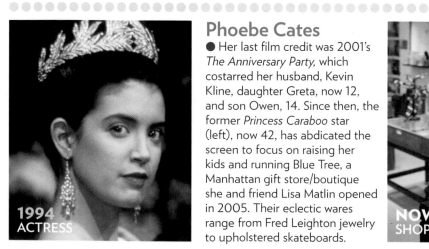

1994
ACTRESS

Phoebe Cates

Her last film credit was 2001's *The Anniversary Party*, which costarred her husband, Kevin Kline, daughter Greta, now 12, and son Owen, 14. Since then, the former *Princess Caraboo* star (left), now 42, has abdicated the screen to focus on raising her kids and running Blue Tree, a Manhattan gift store/boutique she and friend Lisa Matlin opened in 2005. Their eclectic wares range from Fred Leighton jewelry to upholstered skateboards.

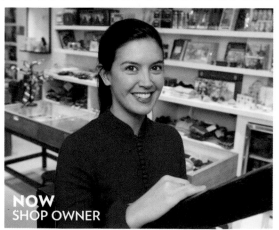

NOW
SHOP OWNER

NOW
PARAMEDIC

1992
90210
ACTOR

Jamie Walters

● He was once engaged to Drew Barrymore (above) and played Tori Spelling's abusive boyfriend on *Beverly Hills, 90210.* Today, if you dial 911 in L.A., paramedic Jamie Walters may respond. "I was 30, it was time to buckle down," he explains. "I got my EMT license and put myself through paramedic school. I was hired by the Los Angeles City Fire Department in 2003. I feel like I'm setting a real example for my children," says Walters, 36, who has three, two of them with wife Patty.

Jenny Jones

● "When I got my talk show," says Jones, "the only thing I asked for was a kitchen in my dressing room so that I could cook." Little did the host of the nationally syndicated *Jenny Jones Show* know she was preparing for her next career. Her successful stint as a daytime doyenne derailed after one of Jones's guests murdered another who'd made a homosexual pass at him and the victim's family won a $29.3 million judgment against the tabloid show's production company and distributor in 1999. Although the verdict was overturned by an appeals court in 2002, the following year the show ended. Prodded by friends to do a cookbook, Jones spent the next year and a half compiling recipes. The result, *Jenny Jones Look Good, Feel Great Cookbook,* was published in April 2006. Now the L.A. resident is working on her next book, *60 Tips for Turning 60* (as she herself did on June 7). And then? "I really feel, at this point, there is nothing I couldn't accomplish," she says.

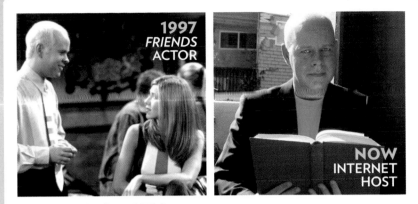

1997
FRIENDS
ACTOR

NOW
INTERNET
HOST

James Michael Tyler

● As Central Perk's Gunther, he served lattes—and punch lines—to the cast of *Friends*. Now Tyler, 44, interviews authors as host of an Internet talk show, expandedbooks.com, and plays keyboard with the ambient band Silliputti.

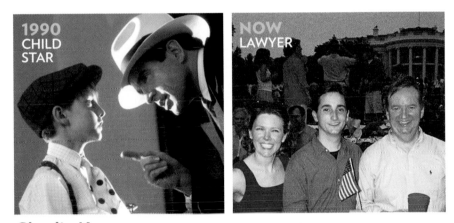

1990
CHILD
STAR

NOW
LAWYER

Charlie Korsmo

● The Kid to Warren Beatty's *Dick Tracy* (above left), Korsmo, 27 (with dad John and stepmom Michelle), went on to work as a Capitol Hill aide before attending Yale Law School (class of '06). He's now weighing an offer as a judicial clerk.

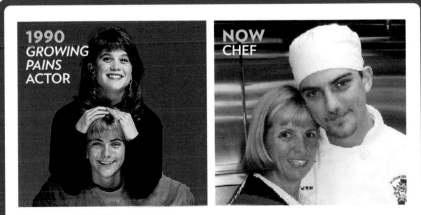

1990
*GROWING
PAINS*
ACTOR

NOW
CHEF

Jeremy Miller

● After costarring with Tracey Gold on *Growing Pains* ('85-'92), Miller, 29 (with mom Sonja), gave up acting for cooking. He has his own L.A. catering biz and is developing a cooking show in China, where *Pains* was a huge hit.

1990
*SAVED BY THE
BELL* STAR

Dustin Diamond

● "There are days when I can't go two feet without being recognized," says Diamond, 29, whom fans know as Samuel "Screech" Powers, the fashion-challenged geek he played on *Saved by the Bell* from 1989 to 2000. "I'm cordial, but it's no longer who I am." Instead, Diamond is on the road up to 49 weeks a year, honing his act as a stand-up comic, performing on college campuses and in local clubs, and is putting together an audition tape for Comedy Central.

NOW
STAND-UP
COMIC

Marcy Walker Smith

● The former Marcy Walker played deceitful Liza on *All My Children* (left) and mysterious Tangie on *Guiding Light*. Today, Smith, 44, married since 2000 to Doug Smith, an IBM exec, sounds more like her soft-spoken *Santa Barbara* character Eden Capwell Castillo as she talks about her role as director of Children's Ministries at Lake Forest Community Church in Cornelius, N.C. "I want church to be a safe place for children where they can bring their hurts, get help and be encouraged," says Smith, who joined the evangelical congregation in 2005. Though she enjoys being recognized by fans, "I'm not seeking celebrity," she says. "I'm fulfilling my life's mission now."

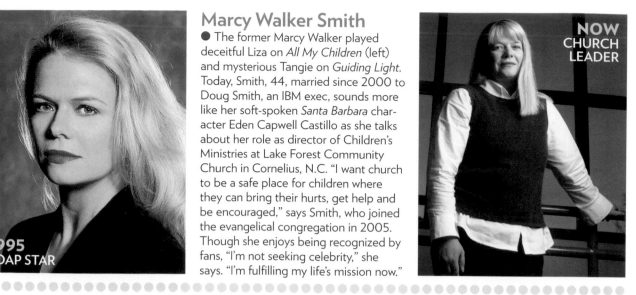

NOW
CHURCH
LEADER

1995
SOAP STAR

NOW
MAGIC
SHOP
OWNER

1990
NIGHT COURT **ACTOR**

Harry Anderson

● As Judge Harry T. Stone, he presided over NBC's *Night Court* from 1984 to '92. These days the actor turned entrepreneur, 53, holds court in New Orleans, where he's trying to lure tourists back to his three French Quarter businesses—including a magic shop and club where he performs tricks—in the wake of Hurricane Katrina. At his club, Oswald's Speakeasy, he says, "I started [weekly] town hall meetings so people could find out what was open; where you could buy food; squelch rumors." Anderson won't give up easily. "You've got to do something," he says. "You can't just let history roll over you."

1992
ACTOR

RICK MORANIS

● The nerdy star of *Honey, I Blew Up the Kid* (above) disappeared from the big screen 10 years ago, only to reemerge in 2006 with *The Agoraphobic Cowboy,* a Grammy nominee for best comedy album. "I wasn't trying to rejuvenate my career," he says. But his daughter, 19, the older of Moranis's two kids with his late wife, Ann, was dating a mandolin player, he says, "and suddenly all this alternative country music was filling up the house and I started writing these songs." What's next? Once his 17-year-old son goes off to college, Moranis, 53, who's still single and lives in New York City, will decide if he wants to resume acting. Meanwhile, he says, "I have wonderful friends and keep myself busy."

NOW
COUNTRY
SINGER

FRESH STARTS

● **CAROL POTTER**

1992
90210 mom

NOW Family
therapy teacher

● **RON DeVOE**

1996
Bell Biv DeVoe
singer

NOW
Realtor in
Atlanta

● **LAUREN LANE**

1997 *The Nanny's*
"C.C."

NOW Texas State
University lecturer

● **TARAN NOAH SMITH**

1993 *Home
Improvement* son

NOW
Vegan caterer

● **JALEEL WHITE**

1990 *Family
Matters'* Urkel

NOW Motivational
speaker

HARD TIMES

Men (and women) behaving badly, actors under the influence, teen idols who grew up too fast . . . rising stars who crashed and sometimes burned altogether. Some are still in trouble, others are starting anew

'94

'00

● BRAD RENFRO

As a teen actor (*Sleepers, Apt Pupil*), the Knoxville, Tenn., native, now 23, proved a natural onscreen. But in 2000, at 18, he was arrested for attempting to steal a $175,000 yacht and sentenced to probation. Busted in '02 for public intoxication, he spent 90 days in rehab. In 2005 he pleaded guilty after he was caught in an LAPD sting operation trying to buy heroin. He got three years' probation and enrolled in a drug-treatment program. "It's been an eye-opener," he said.

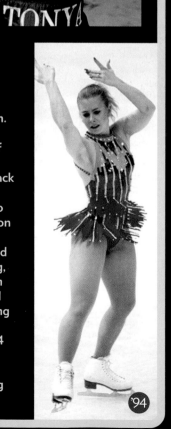
'05

TONYA HARDING

In 1991 she was U.S. figure skating's champion. But three years later, after her ex-husband Jeff Gillooly pleaded guilty to hiring someone to attack rival Nancy Kerrigan, Harding pleaded guilty to hindering the investigation and was sentenced to three years' probation and a $160,000 fine. Harding, now 35, was banned from pro skating but exploited her notoriety in the boxing ring. "I expect the boos," she said before one 2004 bout. "But who's getting the last laugh? They're buying tickets and paying my salary."

'94

'93 '04

● JODIE SWEETIN

After growing up as the middle child on ABC's hit sitcom *Full House,* Sweetin, now 24, saw her career stall when the show ended its run in 1995. In 2002 she wed Shaun Holguin, an LAPD cop. But their marriage fell apart after she got hooked on crystal meth. Sweetin spent seven months in rehab and has been clean and sober since March 2005. She and Holguin are "still very good friends," she told PEOPLE this year.

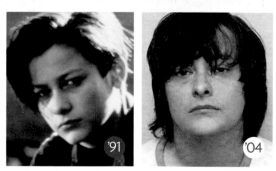
'91 '04

● EDWARD FURLONG

Since his breakout role in *Terminator 2,* Furlong, now 28, has seen attention shift to his personal life. A romance with his 13-years-older manager/tutor ended in a messy breach-of-contract suit in 1999. In 2004 he was charged with alcohol intoxication in a public place after removing lobsters from a Kentucky supermarket tank and was fined $171.50. His latest film, *The Visitation,* casts him as, in his words, "a false prophet."

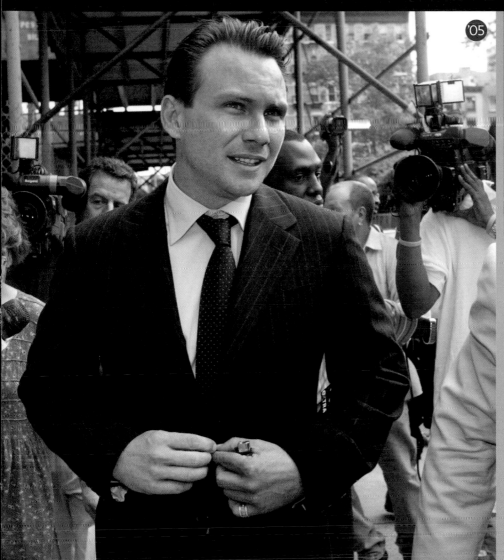

'05

'90

Christian Slater

● The *True Romance* star, now 36, has shown a propensity for offscreen drama as well. Busted for trying to carry a gun onto a plane in '94, he served three days in community service, then served three months for attacking his girlfriend and an LAPD cop in '97. In '05 he was arrested again, after a Manhattan woman told police he'd grabbed her buttocks. He agreed to a plea deal in which the charges would be dropped if he stayed out of trouble for six months.

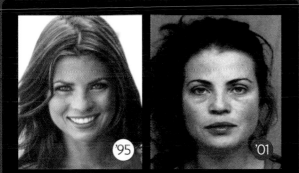

'95 '01

● YASMINE BLEETH

The former *Baywatch* babe, 38, lasted only two seasons on *Nash Bridges* before heading to rehab in 2000 for cocaine addiction. A year later she pleaded guilty to cocaine possession and was sentenced to two years' probation. "Consciously trying to stay off drugs is now part of my daily life," she wrote in *Glamour* in 2003, "and always will be."

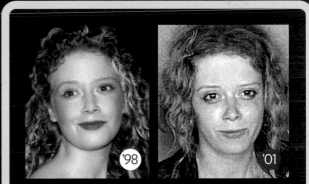

'98 '01

● NATASHA LYONNE

The *American Pie* star was charged with drunk driving in '01, then was arrested again in 2004 for threatening to sexually molest a neighbor's dog. A judge issued an arrest warrant after Lyonne, now 27, skipped two court hearings, but the actress's troubles run deeper. She reportedly spent a month in a hospital in '05, undergoing treatment for hepatitis C and heroin addiction.

:R.I.P.

Actors, rappers, rock stars and royalty, they lived hard, played hard and, sometimes, died hard. These icons were taken too soon

RIVER PHOENIX, 23
● 1993 The *Stand by Me* actor died of a lethal drug combination outside L.A.'s Viper Room.

JOHN CANDY, 43
● 1994 The *Uncle Buck* star's 300-plus-lb. frame and a smoking habit led to a fatal heart attack.

SHANNON HOON, 28
● 1995 Blind Melon's frontman was found dead of a drug overdose on the band's tour bus.

SELENA, 23
● 1995 The Tejana sensation was shot in the back by the former president of her fan club.

Kurt Cobain, 27
● 1994 Struggling with depression and drugs, Nirvana's singer shot himself at his Seattle home, leaving behind wife Courtney Love and their 20-month-old daughter Frances Bean.

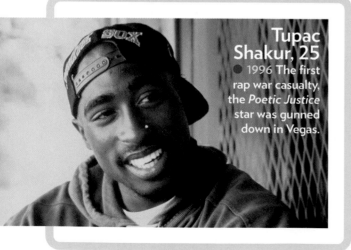

Tupac Shakur, 25
● 1996 The first rap war casualty, the *Poetic Justice* star was gunned down in Vegas.

CHRIS FARLEY, 33
● 1997 After a weeklong drug binge, the troubled comic was found dead in his Chicago apartment.

JEFF BUCKLEY, 30
● 1997 In a freak accident, the singer-songwriter drowned after wading into the Mississippi River.

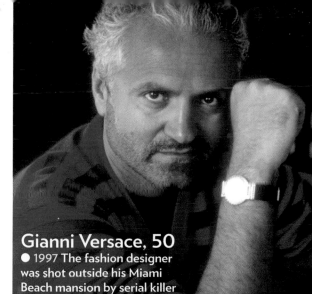

Gianni Versace, 50
● 1997 The fashion designer was shot outside his Miami Beach mansion by serial killer Andrew Cunanan.

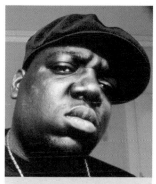

NOTORIOUS B.I.G., 24
● 1997 Biggie Smalls was shot in L.A., apparently a victim of retaliation for the death of Tupac Shakur.

DAVID STRICKLAND, 29
● 1999 Battling depression and alcoholism, the *Suddenly Susan* star hanged himself in a Vegas motel.

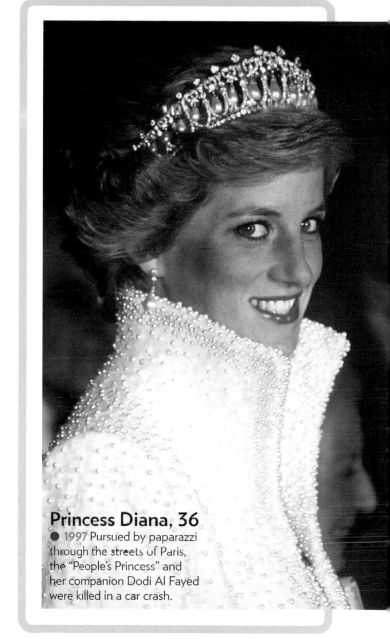

Princess Diana, 36
● 1997 Pursued by paparazzi through the streets of Paris, the "People's Princess" and her companion Dodi Al Fayed were killed in a car crash.

John F. Kennedy Jr., 38
● 1999 En route to Martha's Vineyard for a family wedding, John, his wife, Carolyn, and her sister Lauren went down in the plane he was flying.

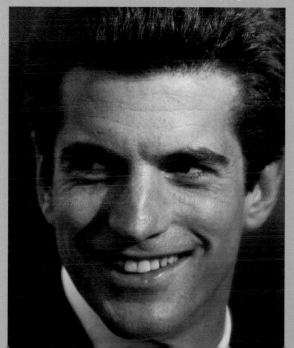

PHIL HARTMAN, 49
● 1998 The comic's wife, Brynn, shot him in his sleep, then killed herself, orphaning their two kids.

MICHAEL HUTCHENCE, 37
● 1997 A month before he was to wed Paula Yates, the INXS singer hanged himself at a Sydney hotel.

WHO ARE THEY NOW?

They got glam and grew up. In the evolution of the species known as '90s notables, these members changed radically

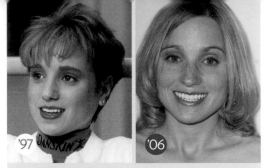

'97 • '06

● **KERRI STRUG** Now 28, the Olympic gymnast has traded her pixie cut for a sleek bob.

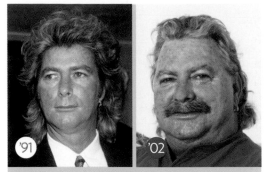

'91 • '02

● **LARRY FORTENSKY** Liz Taylor's ex, now 54, has endured a series of health setbacks.

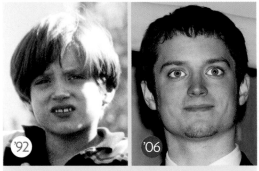

'92 • '06

● **ELIJAH WOOD** At 25, the *Lord of the Rings* star says, "I don't exactly look my age."

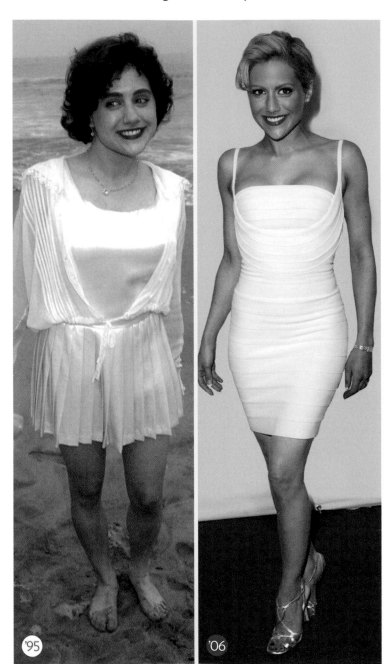

'95 • '06

Brittany Murphy
● Like the character she played in *Clueless*, her breakthrough role, Murphy, 28, has undergone a complete transformation from geek to glam. What's her secret? Says Murphy: "Thank God for tweezers."

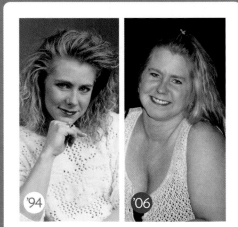

'94 • '06

TONYA HARDING
● The skater turned boxer, now 35, has gained 35 lbs., a result, she says, of steroids she took to treat bronchitis.

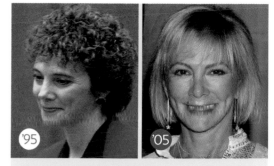

'94 **'06**

Jennifer Lopez

● As a Fly Girl on *In Living Color*, she leaned toward Jenny-from-the-Block street style. Now Lopez, 36 and wed to singer Marc Anthony, goes for haute couture.

'95 **'05**

● **MARCIA CLARK** Making the move from D.A. to TV commentator, Clark, 52, went blonde.

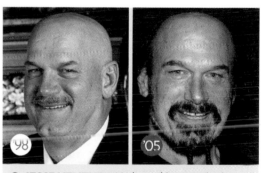

'93 **'06**

● **BILLY RAY CYRUS** In '05, Cyrus poked fun at himself with the song "I Want My Mullet Back."

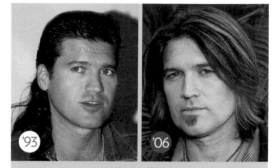

'98 **'05**

● **JESSE VENTURA** He based his new look on Johnny Depp in *Pirates of the Caribbean*.

'92 **'06**

● **KID OF KID 'N PLAY**
Chris Reid lost his 7" high-top fade in the '92 comedy *Class Act*. Now 42 and a stand-up comic, Reid keeps his hair close-cropped.

'98 **'06**

● **SCARLETT JOHANSSON**
Her role in '98's *The Horse Whisperer* showcased her "horribly awkward stage," she says. Now 21, the actress is all glamour.

'98 **'03**

LINDA TRIPP

● Making herself over after the Clinton scandal, Tripp, 56, returned to her brunette roots and underwent a face-lift and chin implant.

:PHOTO CREDITS

● **TITLE PAGE**
1 Laura Farr/Time Life Pictures/Getty

● **TABLE OF CONTENTS**
2-3 (clockwise from left) Rex USA; Polaris; Everett; Urbano DelValle; KRT/Newscom; Everett (2)

● **INTRODUCTION**
4 Bob D'Amico/ABC Photo Archives

● **FASHION**
6-7 Roxanne Lowitt; **8-9** (from left) Berliner Studio/BEImages; Lisa Rose/Globe; Richard Chambury/Globe; Mirek Towski/DMI/Time Life Pictures/Getty; Scott Downie/Celebrity Photo; Nils Jorgensen/Rex USA; **10-11** (from left) Kevin Mazur/WireImage; Tammie Arroyo/IPOL/Globe; Barry King/WireImage; Berliner Studio/BEImages; Spike Nannarello/Shooting Star; **12** (clockwise from top) Robert Trachtenberg/Corbis Outline; Frank W. Ockenfels 3/Corbis Outline; Michael Cali/Rex USA; Ian Tilton/Retna; **13** (clockwise from right) Paul Smith/Retna; Everett; Alex Oliveira/Startraks; Andrea Renault/Globe (2); **14-15** (clockwise from top left) Maria Valentino/MCV Photo; Dana Fineman; Evan Agostini/Getty; Courtesy Calvin Klein; 007/Malibu Media; John Barrett/Globe; Anthony J. Causi/Splash News; Bill McClelland/FilmMagic; Alex Oliveira/Startraks; **16** Everett; **17** (clockwise from top left) NBC/Globe; Lisa O'Connor/ZUMA; Everett; Marko Shark/Corbis; Edie Baskin/Corbis Outline; Robert Hepler/Everett; Jonathan Alcorn/ZUMA; Ron Wolfson/London Features; Michael O'Neill/Corbis Outline; **18** (clockwise from bottom left) Courtesy Thigh Master; James F. Quinn/Chicago Tribune/Newscom; James Keyser/Time Life Pictures/Getty; © Magic Eye Inc. (2); **19** (clockwise from top) David Lawrence; Morton Beebe/Corbis; WHERE'S WALDO? Copyright © 2006 Martin Handford.; © Pikachu Projects/The WB

● **MUST-SEE TV!**
20-21 David Turnley/Corbis; **22** Photofest; **23** (row 1, from left) Amanda Parks/Abaca; Michael Loccisano/FilmMagic; Gilbert Flores/Celebrity Photo; (row 2) Gregory Pace/BEImages; Steve Granitz/WireImage; Zach Lipp/AdMedia; Brian Zak/Gamma; (row 3) Jean Catuffe/INF; Brian Zak/Gamma; Craig Barritt/Bauer-Griffin; Galactic/Star Max; (row 4) Everett; Gerald Martineau/The Washington Post/AP; Michael Schmelling/AP; **24-25** Photograph by Alison Dyer; Set Designer: Robert Summrell/Margaret Maldonado; Hair: (Cynthia and Elaine) Frederick Parnell/Celestine Agency; (Janine) Michelle Vanderpool; (Cynthia and Elaine) Geoffrey Rodriguez/Celestine Agency; (Janine) Michelle Vanderpool; Grooming: (Rob) Jenn Streicher/Solo Artists; (Barry and Darren) Kim Verbeck/Exclusive Artists; Stylist: Julie Weiss/Margaret Maldonado; Clothing: (Rob) shorts, jacket and scarf from Urban Outfitters, shoes by Uggs; (Janine) jacket by Juicy, jeans by Seven, shoes by Rodo; (Barry) vest by North Face, shirt by LaCoste, jeans by Diesel; (Cynthia) T-shirt from Urban Outfitters, jeans by Juicy, shoes by Kenneth Cole, scarf from Intuition; (Elaine) shirt and pants by Lane Bryant, scarf from Intuition; (Darren) shirts from Urban Outfitters; pants by Juicy, shoes by Uggs; **26-27** (left page) CBS/Landov (6); (right page) Alison Dyer (6); (Cullum) Walter McBride/Retna; (Corbett) NPX/Star Max; **28** Foto Fantasies; **29** (clockwise from bottom left) Bill Davila/Startraks; Todd Williamson/FilmMagic; Roger Karnbad/Celebrity Photo; Brian Lowe/JPI; Marc Royce; Tammie Arroyo/AFF; Laura Farr/AdMedia; Gregg DeGuire/WireImage; **30** Everett; **31** (row 1, from left) Pacific Coast News; Peter Kramer/Getty; Janet Gough/Celebrity Photo; (row 2) Ian West/PA/Abaca; Lisa Rose/JPI; (row 3) Denise Fleming/Abaca; Michael Loccisano/FilmMagic; Monty Brinton/CBS; Dan Steinberg/BEImages; (inset) Kinetix; **32-33** (from left) Photograph by Alison Dyer; Hair and makeup: Barbara LaMelza for Exclusive Artists; Grooming: Colleen Campbell for Exclusive Artists; Stylist: Lawren Sample/Margaret Maldonado; Clothing: (Rider) polo shirt by Morphine Generation; (Daniella) T-shirt by Lotta, jacket by Popkiller, necklace by Anna Herrington, denim skirt by Serafontaine; (Ben) T-shirt by Morphine Generation, blazer by Burberry; (Will) shirt by Paper Denim and Cloth, vintage fatigue by Popkiller; Neal Peters Collection; **34** Foto Fantasies; **35** (clockwise from top left) Fanous Mike/Gamma; Grayson Alexander/Retna; Jody Cortes/Everett; Jill Johnson/JPI; Ray Stubblefield/NOF/Reuters; MPTV; Lisa Rose/JPI; Todd Williamson/FilmMagic (2); **36** ABC Photo Archives; **37** (clockwise from top) ABC Photo Archives (3); ABC; Tim Goodwin/Star Max; ABC Photo Archives; Craig Sjodin/ABC Photo Archives; Foto Fantasies; **38** Foto Fantasies; **39** (clockwise from

top left) Bob Riha Jr./WireImage; Jeffrey Mayer/Star File; Joe Brockert; Robin Platzer/Twin Images/FilmMagic; Photofest; Jon Kopaloff/FilmMagic; Kathy Hutchins/Hutchins; Photofest; Carley Margolis/FilmMagic; **40** ABC Photo Archives; **41** (clockwise from right) Ramey; Chris Haston/NBC; ABC Photo Archives; Patrick Rideaux/Rex USA; Jen Lowery/London Features; Paul Mounce/Corbis; Marsaili McGrath/Getty; **42** (from left) Adam Scull/Globe; Mark Seliger/FOX; The Simpsons TM & © 1999 Twentieth Century Fox Film Corporation. All rights reserved.; Everett; Rose Uli/Corbis Sygma; Taco Bell/AP; **43** (from left) Donna Svennevik/ABC Photo Archives; Foto Fantasies; © Comedy Central; Ralph Perou/BBC; Najlah Feanny/Corbis; Everett

● **HOT TICKETS**
44-45 Kobal; **46** (clockwise from top left) Jeffery Mayer/Star File; Michael Germana/Everett; Roger Karnbad/Celebrity Photo; Guy Aroch/Corbis Outline; Getty; Axelle/Bauer-Griffin; **47** Ian White/Corbis Outline; (inset) Hector Mata/AFP/Getty; **48** Photofest; **49** (from top) Everett; People; Donato Sardella/WireImage; Mark Mainz/Getty; Roger Karnbad/Celebrity Photo; **50** Bureau L.A. Collection/Corbis; **51** (clockwise from top left) Amanda Parks/Abaca; Kobal; Everett; Bubba Gump Shrimp Co.; **52** Everett; **53** (clockwise from top left) James White/Corbis Outline; Everett; Courtesy Shelley Michelle; Chen/Celebrity Photo; Eddie Adams/Corbis Outline; Jeff Kravitz/FilmMagic; Steve Granitz/WireImage; **54** Foto Fantasies; **55** (clockwise from top left) Paul Fenton/KPA/ZUMA; Lisa O'Connor/ZUMA; Dimitrios Kambouris/WireImage; Michael Williams/Startraks; Brian Lowe/JPI; People; Reuters; **56-57** (clockwise from left) Alba Montes/Loud & Clear Media; Sipa; Ken Goff/INF; Jerome Ware/ZUMA; Amanda Parks/Abaca; **58** MPTV; **59** (clockwise from top left) Gilbert Flores/Celebrity Photo; David Gabber/Photorazzi; Jemal Countess/WireImage; Clinton H. Wallace/Photolink; Marsaili McGrath/Getty; Corbis Sygma; Jonathan Friolo/IHP/Splash News; Rick Mackler/Globe; Fernando Allende/Splash News; George Pimentel/WireImage; **60-61** (clockwise from top left) Kobal; Everett (2); Tammie Arroyo/AFF; Galactic/Star Max; Doug Peters/Star Max; Francis Specker/Landov; **62** Photofest; **63** (clockwise from top) Everett; Mark Von Holden; Courtesy Joseph Mazzello; Fitzroy Barrett/Globe; Bradley Patrick/Retna; Courtesy Ariana Richards; **64-65** (clockwise from left) Kobal; Jeff Kravitz/FilmMagic; Joe Martinez/MPTV; John Shearer/WireImage; Dave Allocca/Startraks; Eric Weiss/Photolink; People; Rik Sins/Bauer-Griffin; **66-67** (clockwise from left) Photofest (2); Everett (4); Photofest (2); Everett (2); Photofest; Everett

● **POP, RAP & ROLL**
68-69 (center) Michael O'Neill/Corbis Outline; (clockwise from top left) Ronald Asadorian/Splash News; Ferdaus Shamim/WireImage; Fame; Elisabetta Villa/Granata/Photolink; Jo Hale/Getty; **70** Bernhard Kuhmstedt/Retna; (bottom row, from left) Desiree Navarro/FilmMagic; Chris Farina/Corbis; Steve Granitz/WireImage; Dale Woltman/FilmMagic; **71** (from left) Jody Cortes/WENN; Everett; **72** (from top) Neal Peters Collection; Jim Smeal/BEImages; **73** (clockwise from top) Frank Micheletta/Getty; Corbis Sygma; Henry McGee/Globe; Jay Blakesberg/Retna; **74** (clockwise from top left) Tim Boyle/Getty/Newscom; Judie Burstein/Globe; Jim Wilson/Gamma; Jay Blakesberg/Retna; **75** (clockwise from top left) Brian Smith/Corbis Outline; Kramer Giogoli/Vanit/Retna; Evan Agostini/Liaison/Getty; George Lange/Corbis Outline; Mike Prior/London Features; Cathrine Wessel/Corbis Outline; **76-77** (from left) Pycha/Dalle/Shooting Star; Jeff Kravitz/FilmMagic; Ron Galella/WireImage; Paul Natkin/WireImage; Tim Mosenfelder/Getty; Alex Oliveira/Startraks; Mazzoni/ARPF/Shooting Star; Anthony Cutajar/London Features; Armaud Meyer/ARPF/Shooting Star; Ron Galella/WireImage; Allen/Alpha/Globe; Steve Jennings/Retna

● **DO YOU THINK THEY'RE SEXY?**
78-79 Dana Fineman/Vistalux; (inset) Getty; **80** Bob Frame/LaMoine; (inset) Roger Karnbad/Celebrity Photo; **81** Timothy White/Corbis Outline; (inset) WENN/Landov; **82** Charles William Bush/Shooting Star; (inset) Debbie VanStory/iPhoto; **83** Neal Preston/Corbis; (inset) Francois Guillot/AFP/Getty; **84** Lynn Goldsmith/Corbis; (inset) Debra L. Rothenberg/FilmMagic; **85** Terry Williams/London Features; (inset) WENN/Landov

● **NEWSMAKERS**
86-87 Richard Hartog/Los Angeles Times; **88** (clockwise from top) Vince Bucci/AP; Arnold

Turner/WireImage; Flynet; Barry King/WireImage; **89** (clockwise from top left) Reed Saxon/AP; Milan Ryba/Globe; Guy Viau/Courtesy William Morrow; Roger Karnbad/Celebrity Photo; Dimitri Halkidis/WENN/Landov; **90** Everett; Jon Kopaloff/FilmMagic; Adam Knott/Corbis Outline; Kip Rano/Getty; **91** (from top) Patrick Davison/Rocky Mountain News/Polaris; Randy Simons/Polaris; Jeff Kowalsky/ZUMA; **92-93** Jay L. Clendenin/Polaris; (inset) Brooks Kraft/Corbis Sygma; **94** (clockwise from top left) Keri Pickett; Mark Sullivan/WireImage; Harry Cabluck/AP; Richard Drew/AP; **95** (from top) Jim Argo, © 1995, The Oklahoma Publishing Company; Steve Sisney/The Oklahoman/AP; **96** Polaris; **97** (clockwise from top) James Noble/Splash News; Sylvain Gaboury/DMI/Time Life Pictures/Getty; Matt Campbell/AFP/Newscom; Danuta Otfinowski; Mark Wilson/Reuters; **98** (clockwise from bottom) Charley Gallay/Splash News; Marianne Barcellona/Time Life Pictures/Getty; Dick Yarwood/Newsday; **99** (clockwise from top) Ramey; Courtesy California Department of Corrections and Rehabilitation; Tim Boyle/Getty; Corbis Sygma; **100** MPI/Getty; Scott Flynn/AFP/Getty; Robert Holmgren/ZUMA; Everett; Allen Fredrickson/Reuters; Nick Ut/AP; **101** (from left) Lisa O'Connor/ZUMA; Lou Dematteis/Reuters/Corbis; Erica Freudenstein/Corbis Saba; Diana Walker/Time Life Pictures/Getty; Eduardo Di Baia/AP; Karl Gehring/Liaison/Getty

● **THE WAY WE READ**
102 Neal Preston/Retna; Marco Bollinger Photography/Courtesy Susan Powter; People; Jon Farmer/Courtesy Celestine Films; People; **103** (books) People (4); (In the Kitchen with Rosie book) Camilla Zenz/ZUMA/Newscom; (insets, clockwise from top) Cavan Clark/WireImage; Dave M. Benett/Getty; Michael A. Jones/Sacramento Bee/ZUMA; Daniel Snyder/Courtesy Knopf; Courtesy Sarah Ban Breathnach

● **SPORTS**
104-105 Walter Iooss Jr./SI; (insets from left) Ken Babolscay/Globe; Mychal Watts/WireImage; Jim Smeal/WireImage; Courtesy Amanda Borden (3); Jim Spellman/WireImage; **106** Manny Millan/SI; (inset) Johnny Nunez/WireImage; **107** (clockwise from top) Peter Read Miller; Brian Ach/WireImage; Robert Beck/SI; **108** Manny Millan/SI; (inset) Courtesy Kristi Yamaguchi; **109** (clockwise from top left) Kevork Djansezian/AP; Dave Martin/SI; Manny Millan/SI; Beth A. Keiser/AP; David E. Klutho/SI

● **TIMES HAVE CHANGED**
110-111 Sam Jones/Corbis Outline; (inset) SISTERS © Warner Bros. Entertainment Inc. All right reserved; **112-113** (clockwise from top left) Disney; Lucy Nicholson/Reuters/Landov; Andy Paradise/WireImage; Screen Scenes; FOX; John Barrett/Globe; Photofest; Charles Sykes/Rex USA; **114-115** (clockwise from bottom left) MPTV; Frank Micelotta/Getty; Warner Bros.; Jeff Vespa/WireImage; Kobal; Nikki Nelson/WENN; MGM; Alex Berliner/BEImages; **116-117** (clockwise from top left) NBC/Globe; Jill Ann Spaulding/FilmMagic; Everett; Badgley Mischka/Gilles Bensimon; Buena Vista Pictures; Jean-Paul Aussenard/WireImage; **118-119** (clockwise from bottom right) Gamma; Duhamel Francois/Corbis; Kobal; Astrid Stawiarz/Getty; Everett; Steve Granitz/WireImage; Nickelodeon; **120-121** (clockwise from top left) Everett; Photofest; Corbis Sygma; Alison Dyer; Getty; Chris Delmas/Visual Press; Perry Kroll; Everett; **122** (clockwise from top left) Patrick Rideaux/Picture Perfect; Bob D'Amico/ABC Photo Archives; ZUMA; Foto Fantasies; Fernando Allende/NY Post/Splash News; Slaven Vlasic/Abaca; Everett; Tammie Arroyo/AFF; Hollywood Pictures; Lisa Rose/Globe; Kathy Hutchins/Hutchins; Ron Wolfson/London Features; **123** (top row, from left) Photofest; Kathy Hutchins/Hutchins; Kobal; Erica Berger/Corbis Outline; (middle row) Peter Kramer/Getty; Everett; Gamma; Glenn Weiner/ZUMA; (bottom row) Barry King/Liaison/Gamma; Dennis Van Tine/London Features; Photofest; Glenn Weiner/ZUMA; **124-125** (clockwise from left) Gerardo Somoza/Corbis Outline; Albert Ferreira/Globe; Peter Nash; Niviere/Sichov/Sipa; Michael Ferguson/Globe; DMIPhoto; Kelly Jordan/Corbis Sygma; **126-127** (clockwise from left) Photograph by Marc Royce; Hair: Frederick Parnell/Celestine Agency; Makeup: Tena Bernard/Celestine Agency; Stylist: Xavier Cabrera; Clothing: (Tia) shirt by Puella, jeans by Seven; (Tamara) shirt by Westonwear, jeans by True Religion; (Tahj) shirt by Obey, jeans by True Religion; Screen Scenes; Jonathan Exley; Effie Naddel/Everett Collection; Jim Smeal/BEImages; **128-129** (clockwise from bottom left) Linda Vanoff/Corbis Sygma; Lisa Rose/JPI; Emilio Flores/Everett; Jeff Kravitz/FilmMagic; Globe; **130-131**

(clockwise from left) Tara Rochelle; © 2006 Viacom International Inc. All rights reserved; Nickelodeon; Dave Allocca/Startraks; Cooper-Gros/X 17; Everett/Rex USA; David Longendyke/Globe; Ramey; Hutchins; Courtesy Bradley Pierce; Michael Desmond/ABC; Ron Davis/Shooting Star; Andrew Bernstein/Getty; ABC Photo Archives; **132** (clockwise from top left) Zade Rosenthal/TriStar Pictures; William Foster/ZUMA; Leo Sorel/Retna; Everett; **133** Photograph by Alison Dyer; Grooming: Miriam Vukich for Exclusive Artists; (inset) DMIPhoto; **134** Charles Bush/Courtesy Jenny Jones; (inset) Paul Natkin/WireImage; **135** (clockwise from top left) NBC; Everett; Courtesy James Michael Tyler; Courtesy Charlie Korsmo; Courtesy Jeremy Miller; ABC Photo Archives; Jennifer Misner/Courtesy Dustin Diamond Foundation; Neal Peters Collection; **136** (clockwise from top left) ABC Photo Archives; Chris Keane; Foto Fantasies; Andy Levin/Contact Press Images; **137** (Moranis, from top) Everett; Diane Bondareff/Polaris; (Fresh Starts, clockwise from top right) Courtesy Carol Potter; Nick Valinote/FilmMagic; Don Anders/Texas State University; David Livingston/WENN/Landov; Roger Karnbad/Celebrity Photo; Bob D'Amico/ABC Photo Archives; ABC Photo Archives; Everett; Edie Baskin/Corbis Outline; Everett

● **HARD TIMES**
138 (clockwise from left) Stan Grossfeld/Boston Globe; ZUMA; Courtesy Boone County Jail; Peter Brooker/Rex USA; Splash News; Everett/Rex USA; Mike Powell/Allsport/Getty; Bob D'Amico/ABC Photo Archives; **139** (clockwise from top left) Shannon Stapleton/ Reuters/Landov; Robert Schott/Fotos International/Getty; Splash News; Ron Galella/WireImage; Splash News; Neal Preston/Corbis

● **REST IN PEACE**
140 (clockwise from top left) MR Photo/Corbis Outline; Rob Brown; Charles Hoselton/Retna; TJ Collection/Shooting Star; ZUMA; AP; Jon Giron/ Corbis; Corbis Sygma; **141** (clockwise from top left) Alex Quesada/Polaris; KenGoff/INF; Corbis Outline; Fotos International; Brooks Kraft/ Gamma; Andrew Macpherson; Alan Levenson/Getty

● **WHO ARE THEY NOW?**
142 (from left) (Murphy) Jim Smeal/WireImage; Michael Germana/Globe; (Strug) John W. McDonough/SI; Jon Kopaloff/FilmMagic; (Fortensky) Adam Knott/Corbis Outline; Richard Young/Rex USA; (Wood) Kristin Callahan/Ace Pictures; Everett; (Harding) Najlah Feanny/Corbis Saba; Steven Delfalco/Shooting Star; **143** (from left) (Lopez) Michael Ferguson/Globe; Gilbert Flores/Celebrity Photo; (Clark) Globe; Vince Flores/Celebrity Photo; (Cyrus) Michelson/ZUMA; Howard Wise/Shooting Star; (Ventura) Layne Kennedy/Corbis; Gilbert Flores/Celebrity Photo; (Tripp) Richard Ellis/Corbis; Victor Spinelli/WireImage; (Johansson) Photofest; Kevrok Djansezian/AP; (Martin) Warner Bros.; Evans Ward/JPI

● **END PAPERS**
Front Spread (clockwise from top left) Jeff Kravitz/FilmMagic; FOX; Everett; Jesse Frohman/Corbis Outline; Ramey; Everett; CBS/Landov; Kobal; Everett; Bembaron Jeremy/Corbis Sygma; MPTV; Scott Downie/Celebrity Photo; Neal Peters Collection; Merie W. Wallace/Paramount Pictures & 20th Century Fox; Photofest; Eugene Adebari/Rex USA; Everett (2)
Back Spread (clockwise from top left) ABC Photo Archives; Tim Rooke/Rex USA; Mario Casilli/MPTV; Everett; Anthony Cutajar/London Features; Andre Csillag/Rex USA; L.A. Bureau Collection/Corbis; Corbis Sygma; Everett; Chris Carroll/Corbis Outline; Ann States; Doug Hyun/FOX; Michael Halsband/Time Life Pictures/Getty; Kobal; Jack Chuck/Corbis Outline; Everett; David M. Moir/Dimension Films; Neal Peters Collection

● **COVERS**
Front Cover (row 1, from left) Merie W. Wallace/Paramount Pictures & 20th Century Fox; Gamma; (row 2) Everett; Foto Fantasies; Photofest; David Turnley/Corbis; Everett; (row 3) Mario Casilli/Shooting Star; Michael O'Neill/Corbis Outline; James Keyser/Time Life Pictures/Getty; Greg Gorman/FOX; Mario Casilli/MPTV; (row 4) Nubar Alexanian/Woodfin Camp; Elliott Marks/Paramount Pictures; Norman Ng/Celebrity Pix/Corbis Outline; Andrew Cooper/Columbia TriStar Pictures; Mike Ruiz/ContourPhotos
Back Cover (row 1, from left) Norman Ng/Celebrity Pix/Corbis Outline; Rien/Corbis Sygma; Jim Wright/Icon; Guy Aroch/Retna; (row 2) John McCoy/AP; © Nintendo; David Strick/Corbis Outline; (row 3) CBS/Landov; ABC Photo Archives; Everett (2); (row 4) Bureau L.A. Collection/Corbis; Kwaku Alston/Corbis Outline; Jay Blakesberg/Retna